IMAGES
of America

DES MOINES
1845–1920

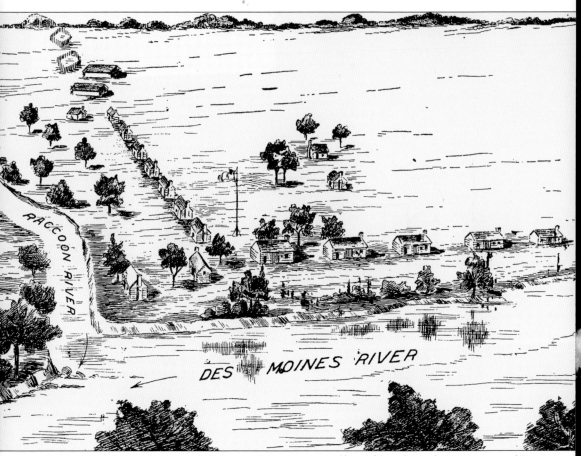

In 1843, Fort Des Moines was little more than two rows of log cabins along the Raccoon and Des Moines Rivers, as demonstrated in this drawing by noted Polk County historian Tacitus Hussey, from his book *Beginnings: Reminiscences of Early Des Moines*, published in 1919.

IMAGES
of America

DES MOINES
1845–1920

Craig S. McCue

ARCADIA
PUBLISHING

Published by Arcadia Publishing
Charleston SC, Chicago IL, Portsmouth NH, San Francisco CA

Printed in the United States of America

Library of Congress Catalog Card Number: 2006926492

For all general information contact Arcadia Publishing at:
Telephone 843-853-2070
Fax 843-853-0044
E-mail sales@arcadiapublishing.com
For customer service and orders:
Toll-Free 1-888-313-2665

Visit us on the Internet at www.arcadiapublishing.com

*For my grandfather Merlyn L. "Mack" McIntyre (1921–2006),
who gave me a love of history, and for my children, Christian
Haas and Hannah McCue, to whom I hope to pass along that love.*

CONTENTS

ACKNOWLEDGMENTS

This book would not have been possible without the help of Lorna Truck, Pam Deitrick, Elaine Estes, and other staff members and volunteers of the Des Moines Public Library who patiently endured my many comings and goings over several weeks in preparation for this work. I want to express my gratitude to those who have donated photographs and other artifacts to the Des Moines Public Library for the enjoyment of all. I also appreciate Cory Heintz and Bob Krouse of the Iowa Department of Transportation (IDOT), for making available scans of historical photographs in the IDOT archive.

A tremendous collection of historical research was provided by the following: Kelly Shaw, Marion John Rice, and the other volunteers of the IAGenWeb Project's Polk County Web site (http://www.iagenweb.org/polk), Dick Barton and the other volunteers at the Iowa Biographies Project (http://www.rootsweb.com/~iabiog), Darlene Coover and the other volunteers at USGenNet (http://www.usgennet.org), and Distant Cousin (http://www.distantcousin.com). Thanks also go out to the many antique and used-book dealers I have interacted with over the years, who care enough about history to preserve it for future generations.

Many photographs in this work come from various sources, most of which are now part of my personal collection. For convenience, source references are abbreviated as follows:

Atlas: *Andreas' Illustrated Historical Atlas of Iowa*, 1875
BTH: *Beginnings: Reminiscences of Early Des Moines* by Tacitus Hussey, 1919
CHDM: *Centennial History of Des Moines* by J. M. Dixon, 1876
DMAR: City of Des Moines Annual Reports, 1908–1915
DMB: *Des Moines Beautiful* by Enos B. Hunt Jr., 1910
DMIS: *Des Moines Illustrated Souvenir* by the Iowa Historical Illustrative Company, 1895
DMPL: Des Moines Public Library Photograph Collection
Harpers: *Harpers Weekly: A Journal of Civilization*, 1861–1862
HDM: *History of Des Moines and Polk Country, Iowa* by Johnson Brigham, 1911
IDOT: Iowa Department of Transportation Photograph Collection
LOC: Library of Congress Memory Archive
MSPDM: *Major Street Plan of Des Moines* by Des Moines Zoning Commission, 1925

INTRODUCTION

Before the 19th century, the land between the Mississippi and Missouri Rivers was a wilderness. In other areas of settlement in North America, pioneers had the benefit of trails used by Native Americans and the guidance of those people in exploring the countryside. However, in what became the state of Iowa, even the Native American presence had only recently been introduced, although there were mysterious burial mounds dating back hundreds of years.

Explorer Louis Jolliet and missionary Father Marquette first explored the upper Mississippi valley in 1673. They landed near the mouth of a swift-flowing river entering the Mississippi and followed its trek westward about six miles, until they reached a small Sauk village called Moinguena, from which the explorers named the river they had just discovered: Riviere des Moingona. Through association with the monks that later settled along the mouth of that river, and possibly due to the existence of the nearby mounds, this name eventually became the Riviere des Moines, or River of the Monks.

About this same time, members of the Asakiwaki (Sauk) and Mesquakie (Fox) tribes, recently driven out of their homes along the St. Lawrence River, settled in the Midwest as far as Kansas, with many taking up homes in the Des Moines River valley. There they found an offshoot of the Otoe, known to explorers as the Ioway, as well as other bands of Lakota from the upper Missouri valley. Unfortunately, the various tribal nations were frequently at war with each other.

Along the Mississippi, trappers and explorers began to establish colonies for the purpose of trading, establishing mining operations, and processing fur and other goods to be sold in city markets. And a few of these managed to work their way inland into the wilderness, including one Jean Baptiste Faribault, an agent of the Northwest Fur Company, who established trade relations with the Native Americans living along the Des Moines in 1798. To support his mission, he built a small post named Redwood about 200 miles from the mouth of the river. Such a distance, if accurate, would certainly place the post near the vicinity of the Raccoon Forks area, if not beyond.

Ownership of the region nominally passed from French to American control with the Louisiana Purchase of 1803. However, Native American claims continued. Conflicts between the various tribal groups and with westward-bound white settlers resulted in several incursions, culminating in the Black Hawk War of 1832 and the near extinction of the Ioway nation. To settle the differences, the United States government stepped in and negotiated several purchases, set up a neutral zone, and began to explore the territory.

To this end, an exploration team, including Col. Stephen Kearny and Lt. Albert Lea, worked their way up the Des Moines River, reaching the Raccoon in the summer of 1835. Lieutenant Lea

reported favorably on the Raccoon Forks region, but Colonel Kearny strongly opposed building a fort there. Nathaniel Boone took another group to the same area in August of that year. Lt. John C. Fremont conducted another survey in 1841, briefly visiting the nearby American Fur Company post.

Also in 1835, a band of Sioux ambushed a group of Delaware; only one person survived to tell the tale. A Sauk chief, Pashepaho ("The Stabber"), then camped at the current site of the state capitol, sought revenge. Organizing a war party with neighboring Mesquakie, he led a large group against the Sioux, killing over 300 in the engagement. Such occurrences led the country to sign a treaty with Keokuk, chief of the Sauk, and Poweshiek, chief of the Fox, to cede all land claims to the United States in return for annual payments and relocation to the Indian Territory. The treaty would go into effect in May 1843, and the transfer would occur after a three-year period. To keep the peace, a temporary fort would be built on the Des Moines River, near the Raccoon Forks area, manned by a company of dragoons and another of infantry. The responsibility for building and manning this fort fell to Capt. James Allen.

Supplies were sent up with the steamer *Ione*, while another company arrived later via the *Agatha* on May 20, 1843. Meanwhile, the infantry company made its way overland from Fort Crawford, arriving at the fort site the following day. Captain Allen's first proposal, to name the fort after the Raccoon River, was met with derision, and Gen. Winfield Scott decided on the name Fort Des Moines. It was built along the sides of the two rivers, with the officers lined up along the Des Moines and the enlisted men along the Raccoon. After the treaty period ended, the fort was vacated in March 1846. A few months later, Lieutenant Grier, now in command of the dragoon company, returned to Fort Des Moines. Here he found a small group of settlers who had moved into the abandoned cabins. They had already organized a rudimentary government and had proclaimed the settlement the county seat of the newly formed Polk County.

Thus was the city of Fort Des Moines born.

One

FRONTIER TOWN

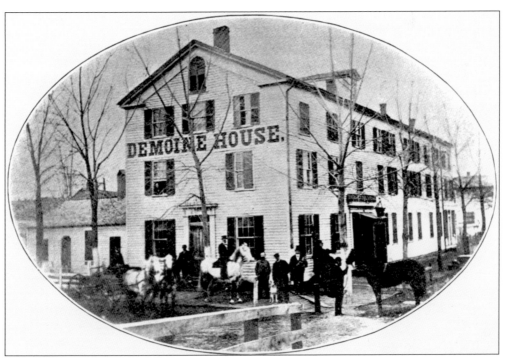

The Demoine House was not, as many believe, the first hotel in Fort Des Moines. Others had in fact been established—some in former barracks and one in an old blacksmith shop. Originally named the Pennsylvania House, the hotel relocated to the corner of First and Walnut Streets and was rechristened after a popular, although controversial, spelling of the city's name at the time. The opening night of July 4, 1855, was marred by tragedy when a young man mistook a bottle of corrosive cleaning solution for whiskey and died that evening during the festivities. Operating until 1877, the Demoine House proved to be the first residence of many settlers in the early years of the city and was a popular nightspot, featuring dances and other entertainment. (BTH.)

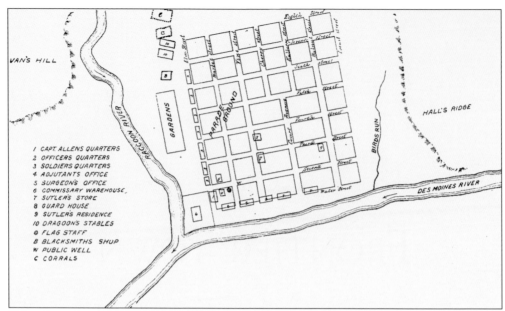

Taken from the plat of 1846, this map (originally drawn by Tacitus Hussey) shows the locations of the fort's original buildings. Little more than log cabins, they were settled by many of the prominent early founders of the city, including Isaac Cooper; Barlow Granger; brothers Hoyt, James, and Lampson Sherman; P. M. Casady; B. F. Allen; and Drs. Grinnell and Fagan. Most of the cabins did not survive much past the 1860s. (HDM.)

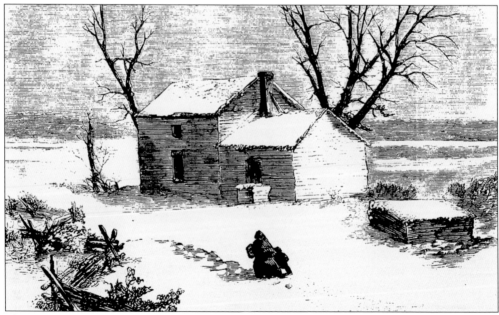

The Raccoon River Indian Agency was the center of trade with the Sauk and Fox tribes in the region until the territory was transferred to United States control. The building was torn down in 1861 to make way for a street extension. Recent surveys by Martin O'Line place its location somewhere around East Sixteenth Street to Eighteenth Street and between Court and Dean Avenues, along the old road to Iowa City. (Harpers, February 9, 1861.)

10

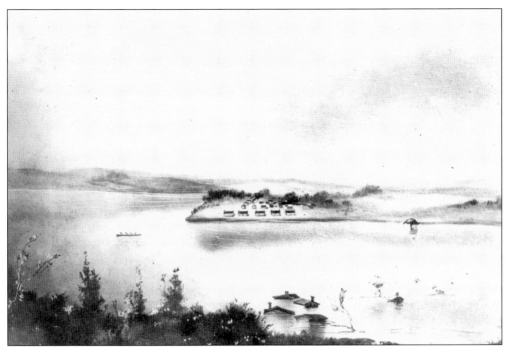

The flood of 1851, depicted in this painting, nearly doomed the small community. Cut off from all contact for several weeks, a small group led by Hoyt Sherman set out to St. Louis on May 29, 1851, in hopes of bringing supplies back to the city. They arrived on the steamboat *Caleb Cope* on July 5th, to the relief of the townspeople. Although the flood had subsided somewhat, the steamboat was still able to take several groups as far as Beaver Creek before returning to Keokuk. (HDM.)

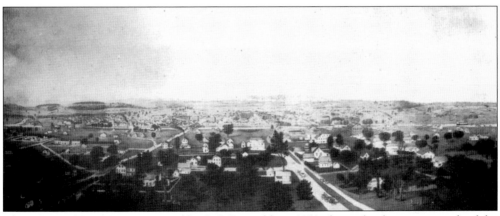

This image of Des Moines, painted by G. I. Reynolds in 1858, shows the dramatic growth of the city. Although still largely a frontier town, Des Moines grew steadily and prospered during the 1850s due to the twin migrations of 49ers seeking gold and Latter Day Saints heading toward Utah. However, its size in 1860 of approximately 4,000 people was still dwarfed by the trading towns of Keokuk, Davenport, and Dubuque along the Mississippi. (HDM.)

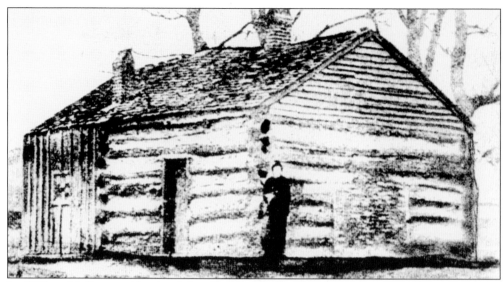

Lt. William N. Grier and his family lived here while Fort Des Moines was still an army post, thus making it officially the first house in Fort Des Moines. Lieutenant Grier's infant son was the first to be born in the city, and the first to die as well; Ezra Rathbun, the Methodist exhorter and circuit minister, gave the service. The house survived to the 20th century, and for a time was the only relic left of the original fort, until it too was demolished for safety reasons. (LOC.)

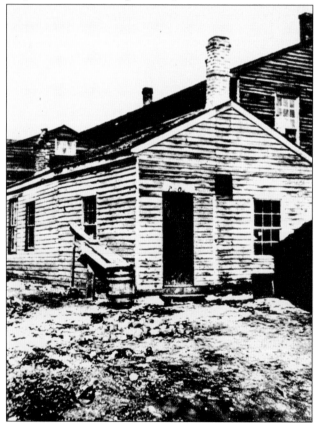

The first post office, seen here, was built in 1850 by Hoyt Sherman, postmaster at the time. Located at the corner of Second and Vine Streets, it served for many years until replaced by a new facility at Third Street and Court Avenue. (LOC.)

Dr. Francis C. Grimmel constructed the first frame house in Des Moines, near the corner of Sixth and High Streets. He owned much of the land around that area and eventually subdivided it into residential lots for many of the more successful early pioneers of the city. His daughter Augusta later became the wife of P. M. Casady. (DMPL.)

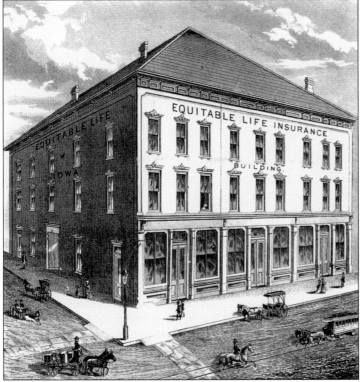

In 1853, Hoyt Sherman built the first three-story block, at the northeast corner of Third Street and Court Avenue (now the site of the new federal building). Although originally containing a number of different shops and offices, it eventually became the headquarters of Equitable Life (now a subsidiary of ING), organized by Fred Hubbell. (Atlas.)

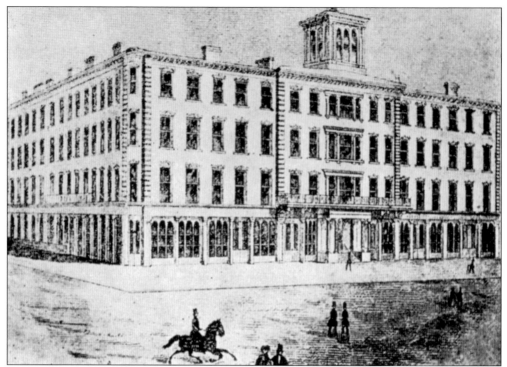

The first Savery House was constructed in 1856 by James C. Savery at the current location of the Kirkwood Hotel on Fourth and Walnut Streets. It was the first modern hotel in Des Moines and developed a good reputation. Unfortunately, Savery had to sell his hotel to pay debts. In 1878, the house was extensively remodeled and renamed the Kirkwood, after Iowa's wartime governor and statesman. (BTH.)

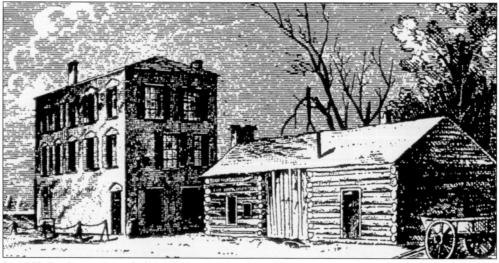

In 1855, Dr. James Campbell built the first brick building in Des Moines, at Raccoon Point, as an ear and eye clinic. A medical doctor by profession and a merchant by trade, he ran a general store on Second and Vine Streets for many years. Dr. Campbell served as the city treasurer for a time, but his life pursuit involved researching cures for eye ailments, a study of personal interest due to his own poor eyesight. (BTH.)

Des Moines's first church was constructed on Fourth Street by Central Presbyterian, founded in 1853 by pioneer minister Thompson Bird, a missionary for the American Home Missionary Society. Although there had been other religious groups in the city, some of which met in meeting halls, school buildings, or courthouses, this was the first building used exclusively for that purpose. Reverend Bird was also instrumental in founding Plymouth Congregational Church, because his missionary society was a joint effort by those two denominations. The church burned down in 1867. (BTH.)

Although education of children occurred from the earliest days of the fort, the first public school, known as the original Third Ward School, was constructed in 1855 on Ninth and Locust Streets. The building was also used as a meetinghouse for both the Lutheran and Christian churches before it was torn down in 1869. (BTH.)

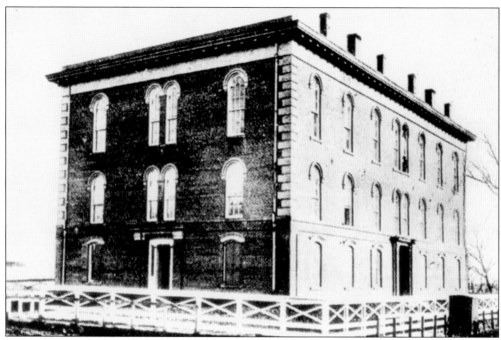

This brick building was the seat of Iowa's government from 1857 to 1886 and was quickly erected as an enticement to locate the capitol on the east side of the river. When the present capitol was completed, this structure was used for storage until destroyed by fire in 1892. In its place stands the Soldiers and Sailors Monument. It is referred to as either the second or fourth capitol, depending on whether territorial capitols are considered. (LOC.)

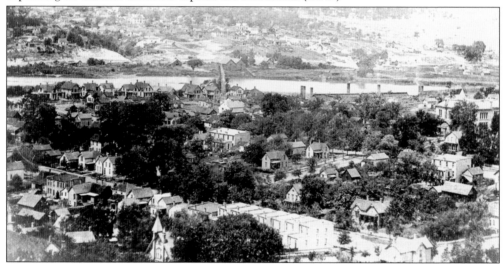

Looking northwest from Capitol Hill, this view shows many of the early residences on the east side. Across the river is Hall's Ridge, which was proposed as the capitol site by those residents on the west side. For a time the battle between East and West Des Moines threatened the capitol relocation, until each side agreed to merge the communities into one united city. After the capitol was located on the east side, the ridge became dotted with industrial and residential properties until the development of the Des Moines Freeway (Interstate 235), when the River Hills urban renewal area was formed in 1961. It is now home to the Iowa Events Center. (DMPL.)

The city's first federal building was authorized by Congress in 1865. Due to the rampant real-estate speculation of the time, the search for a site was conducted secretly. The final location at Court Avenue and Fifth Street was purchased, and the entire structure was completed in 1871 at a cost of $210,000. It contained not only the post office, but also the revenue collector, land office, and federal courtrooms. (DMPL.)

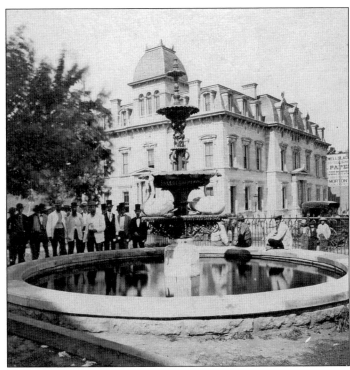

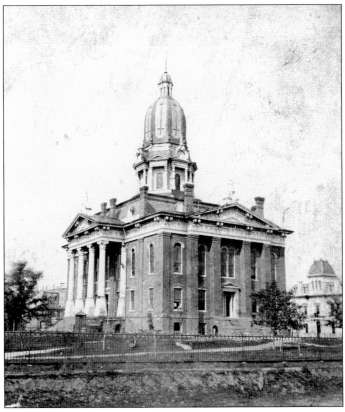

Shown here is actually Polk County's second courthouse, the first having been built in 1850 on Cherry Street, the later site of Union Station. This courthouse was constructed in 1859 at a cost of $100,000. The jail was in the basement, as were offices for the local constables. (DMPL.)

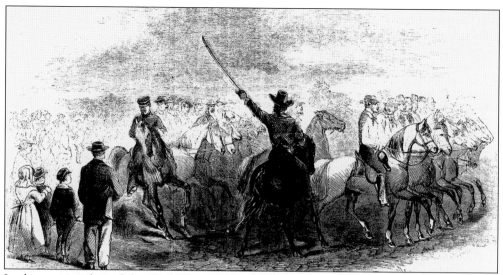

In the opening days of the Civil War, support for the Union cause flowered throughout Iowa, and Des Moines was no exception; here, the 2nd Iowa Cavalry leaves the city for the battlefront. In fact, the governor did not hold a regular draft for the war, so dramatic were the numbers of volunteers offered to the conflict. As the war continued, groups of women advertised that they would work the job of any able-bodied man willing to volunteer for service, and take no pay for their effort. (Harpers, September 21, 1861.)

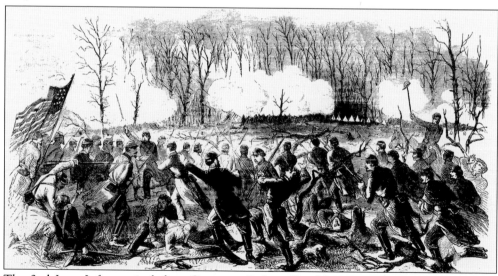

The 2nd Iowa Infantry, including Company D from Des Moines, was organized under the command of General Grant, who put them on the pickets for the siege of Fort Donelson in Tennessee. Their legendary charge against Confederate forces broke through the lines and led to the capture of the fort. They continued to follow Grant to other victories, though costly, at Pea Ridge, Shiloh, and Vicksburg. (Harpers, March 15, 1862.)

Des Moines was still very much a frontier town, even into the 1870s, as evidenced by this view of Walnut Street between Third and Fourth Streets. The Iowa Business College and the Washington Life Insurance Company are the first signs of the commercial center Des Moines would later become. (DMPL.)

In this view along Walnut Street, looking east from Fifth Street, is another sign of a changing Des Moines: the first street railway lines, almost covered in the muddy dirt roads of the early 1870s. Using horse-drawn trolleys, the first line was a simple loop running down Court Avenue to the courthouse, across Fifth Street to Walnut Street, and then back up to East Seventh Street near the capitol. To complete the loop, an alleyway was traversed behind East Seventh Street. (DMPL.)

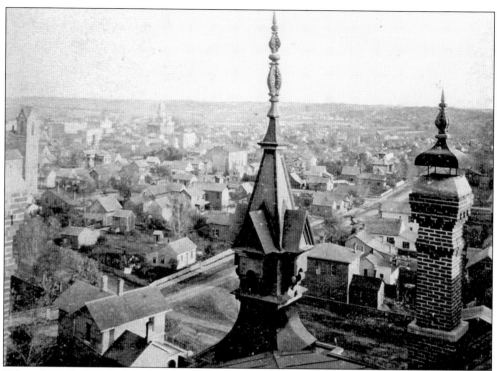

Taken from the roof of the new Third Ward Schoolhouse at Tenth and Pleasant Streets, this view shows (from left to right) the steeple of Central Presbyterian Church, the Second Ward Schoolhouse, and Polk County Courthouse. This structure replaced the original (seen on page 15) in 1870. (DMPL.)

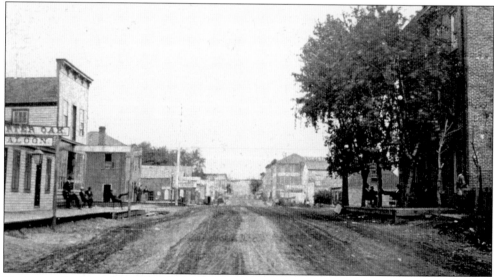

Taverns and saloons lined Third Street during this time. Temperance was a hot issue in 1870s Iowa, limiting the number of saloons permitted per capita. Eventually the state legislature voted to make the state dry in 1882. After the ruling was overturned by the supreme court, the legislature tried again two years later. A local option rule was instituted in 1893, but Prohibition was again passed in 1916, four years before the 18th Amendment was ratified. (DMPL.)

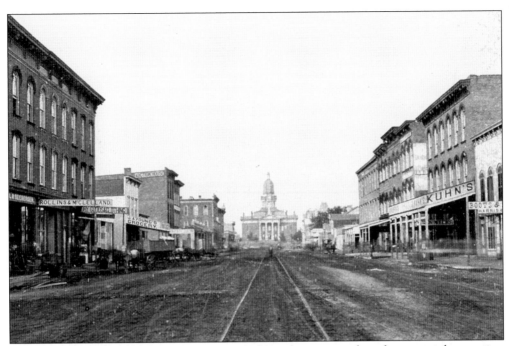

This view of the courthouse from Court Avenue shows the great number of commercial enterprises in operation in the area. By this time, the central business district had moved from Second Street to Third and Fourth Streets between Court Avenue and Locust Street. The business district's slow drift northwest continues to this day in downtown Des Moines. (DMPL.)

Looking north from the courthouse, this view reveals the extent of the downtown area, as well as the residential communities beyond. While many of the businesses in this area supplied construction and industrial needs, many larger commercial buildings also operated. Ultimately, this would become the financial district of the city. (DMPL.)

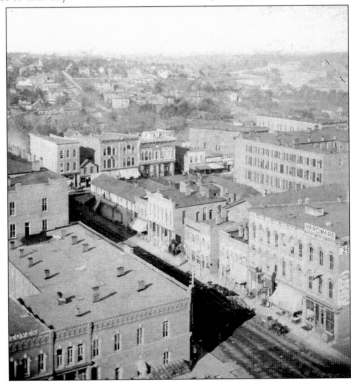

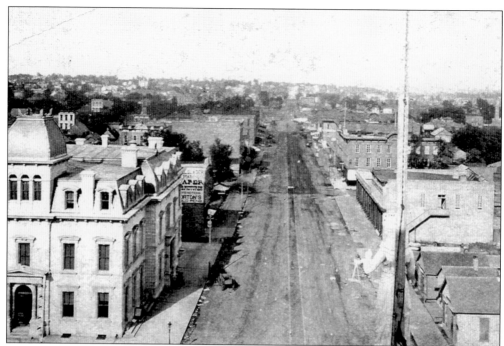

Looking east of the courthouse, this view shows the federal building and post office, and what would eventually become the location of the state capitol, which in the early 1870s was still under construction. In this photograph are other indications of advancing technology: telegraph and electrical poles. The telephone would come soon after, in the early 1880s. (DMPL.)

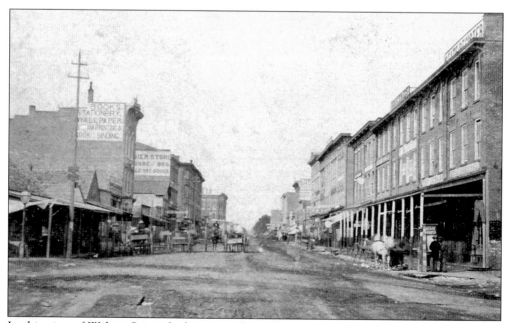

In this view of Walnut Street, looking west from Third Street, the Exchange Block stands on the right. Constructed in 1856 (the awning was added later), the early commercial block served as home to a number of pioneer businesses. (DMPL.)

Two

CAPITAL BOOM

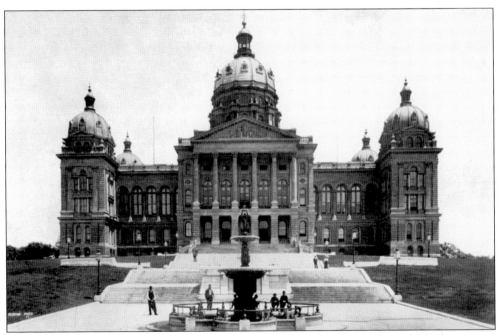

In the 1850s, the population of the state shifted westward, and many people looked to a new, more centrally located capital city. Fort Des Moines was a likely choice, but other locations were being considered as well. A truce between West Des Moines and East "Demoine" enabled a united city to present its case. Ultimately, though, the deal depended highly on a promised railroad from Keokuk to Des Moines. With the backing of the largest county in the state at the time, Des Moines won the battle by a slim margin. Unfortunately, the truce between east and west broke down as the two sides fought for the actual capitol site. The west side offered Hall's Ridge, with much acreage offered for a large campus. The east side offered a much smaller plot, but threw in a hastily built brick building as an incentive. The selection of the east-side site brought charges of corruption, but in the final analysis the state needed a capitol, though temporary, to conduct business. (DMIS.)

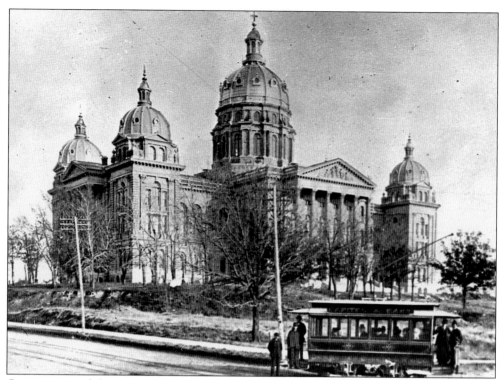

Construction of the permanent capitol began in 1870. Due to financial issues with the brick structure, the new one was to be built as funds became available. The foundation was laid in 1870, but had to be relaid in 1873 because of faulty stone. The capitol was dedicated in 1884, although construction actually continued until 1886. (IDOT.)

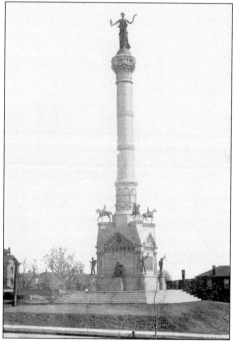

To commemorate the sacrifices of Iowa veterans during the Civil War, the Soldiers and Sailors Monument was built at the site of the second capitol in 1898. Controversy prevented it from being formally dedicated until the last months of World War II, however. The homes and businesses surrounding the monument were later removed during an expansion of the capitol grounds.

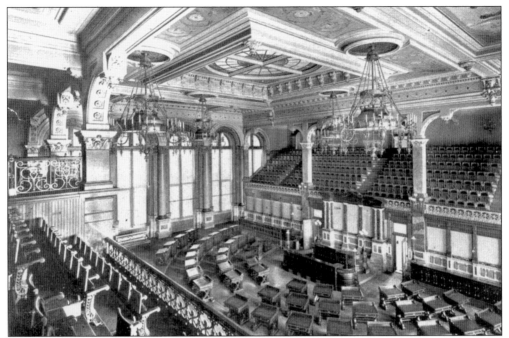

The senate chamber looks much the same today as when it was first used in the late 1880s—even the gas chandeliers, which have since been rewired for electricity. The desks and other furnishings pictured here are still used. (DMIS.)

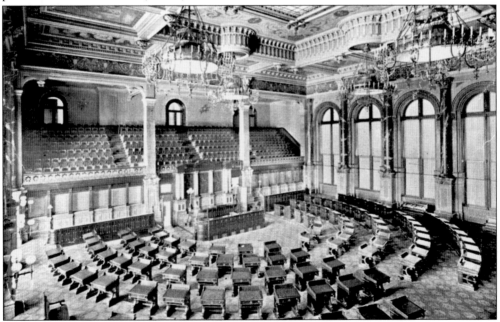

The House of Representatives chamber is shown in 1895, before this wing of the capitol was damaged by a January 1904 fire. During the blaze, one of the firefighters in the attic fell through the ceiling and died on the floor of the House chamber. After the fire was extinguished, the assembly decided to continue meeting here during repairs, even though the damage was extensive. (DMIS.)

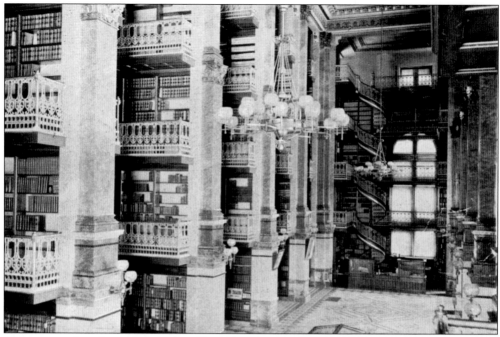

This view, taken from the north gallery, depicts the state library. During the fire of 1904, improvised chutes carried books out the windows before the fire could reach this section of the capitol. Fortunately, the blaze never touched the library, and local volunteers and high school students spent the next week replacing the volumes. (DMIS.)

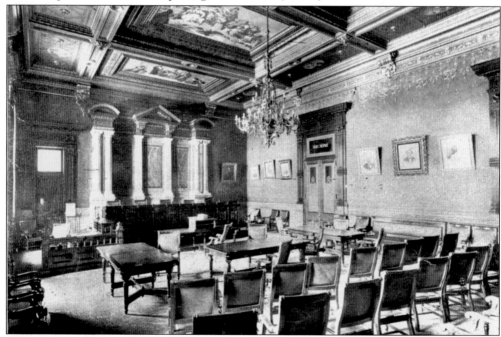

The supreme court chamber is situated beneath the state library. Because of the efforts to fight the fire on the capitol's second floor, water seeped into the chamber, destroying the frescoes and artistic flourishes seen here on the walls and ceiling. (DMIS.)

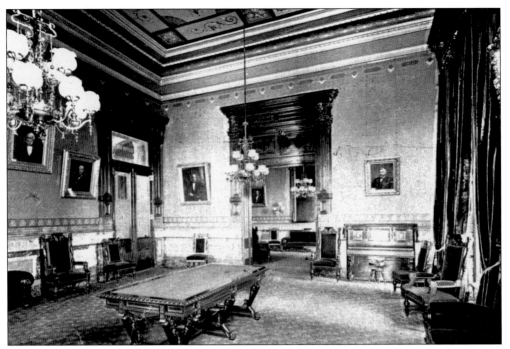

The reception room of the governor's office was used for cabinet meetings and other formal functions. It became the lieutenant governor's office after a remodeling effort was completed in 1999. (DMIS.)

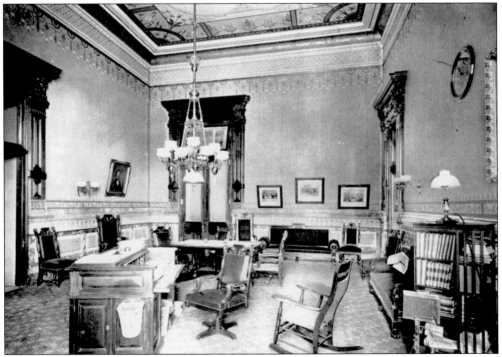

Seen here is the governor's private office. Used first by Governor Sherman in 1885, it has since been used for the same purpose, though lately for more ceremonial uses. (DMIS.)

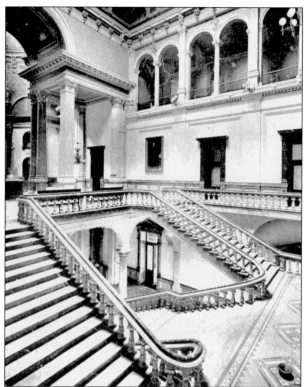

The grand stairway in the rotunda connects the first floor, containing the governor's offices and supreme court chambers, with the second floor, where the senators and representatives of the general assembly meet. (DMIS.)

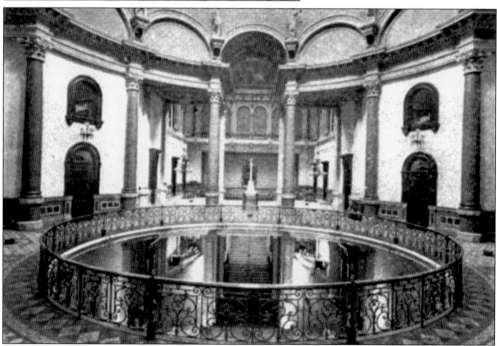

Although the capitol was completed in 1886, funds were not available to paint the artwork in the rotunda, as demonstrated in this c. 1890 view. One of the results of the fire of 1904 was a budget to complete the paintings originally planned for this area. (DMIS.)

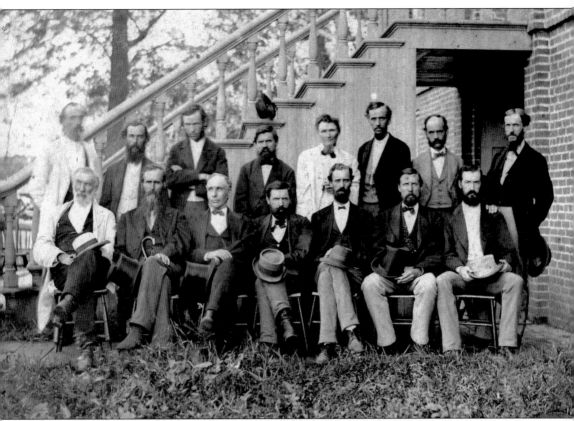

This portrait of the governor and his cabinet was taken in 1873. The dour expressions often found on photographs taken during this time had more to do with the long sitting time than with the temperament of the subjects. But one local commentator had a bit of fun with the subject, declaring that the administration was "Caught at last!" Included in the first row (from left to right) are Col. Aaron Brown (register of the state land office 1871–1875), "hunting up a tract of swampland on which to colonize the luckless picture taker"; Maj. Samuel E. Rankin (treasurer 1867–1873), who "protests and has concluded that it didn't do any good"; John Russell (auditor), looking "as if he were about to mail an excuse for being caught in bad company"; Gov. Cyrus C. Carpenter (1872–1876) "making up his mind to refuse the photographer a pardon"; Gen. Ed Wright (secretary of state 1867–1873), who apparently "went to sleep in the midst of the transaction"; Col. Alonzo Abernathy (superintendent of public instruction 1872–1876) "thinking more about school district number 9 than of photography"; and Judge Alexander Robert Fulton (secretary board of immigration) "looking as if he had just discovered the man that stoled his pocketbook." In the background are several junior officers of the administration, "a solemn column of clerks lined up against a solid brick wall that sets the whole scene out with a reminder of the place where men are locked up for infringement of the law". The commentator concludes that "They are the most mournful looking lot of men that were ever printed on paper, and the photographer deserves to be dealt with without the benefit of clergy." (DMPL.)

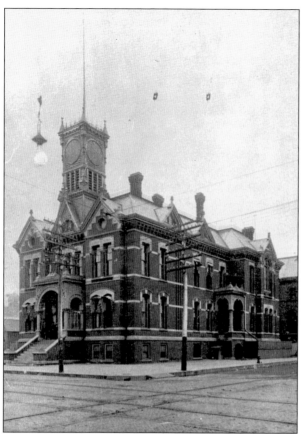

This is the second city hall building, constructed in 1882 on the site of the original. In later years, it unfortunately became associated with many of the political manipulations and backroom deals that characterized the mayor's office. This ultimately led to a progressive revolution and the adoption of a city council, or commission, form of government. Known as the Des Moines Plan, it became famous throughout the country. As a result, when the new city hall was built in 1909, it was named the municipal building to remove the taint of the former association. (DMIS.)

The Chicago and Great Western Railroad passes in front of the Seventh Street bridge across the Raccoon River. Farther down is the Fifth Street bridge, which closed to the public in 1993 but still stands. In the distance are the Observatory and old Equitable Buildings downtown, and the capitol across the river. (DMPL.)

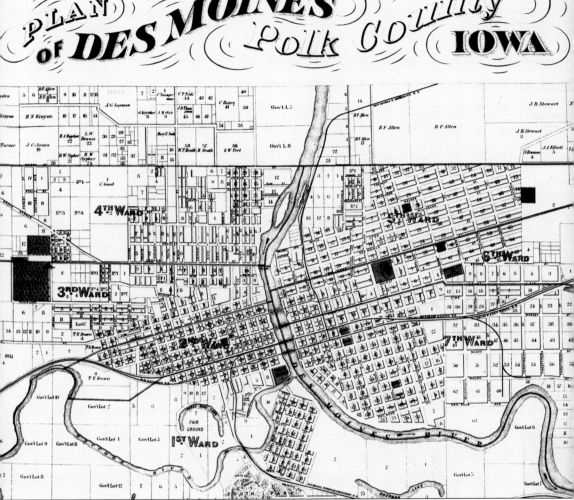

This map shows the extent of Des Moines from 1857, when it became Iowa's capital, to 1890—a mere eight and three-fourths square miles. Some landmarks include Sycamore (Grand) Street and the very beginnings of North (University) Street's extension. Also present are the five railroad lines in the city at that time and the first trolley loop, which ran up Walnut and Locust Streets from the courthouse to the capitol. (Atlas.)

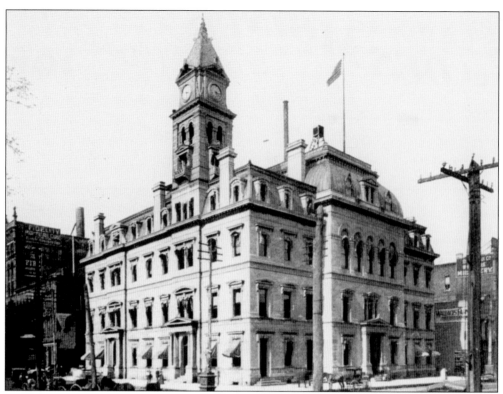

In 1890, the federal building was expanded to include a fourth floor and tower. Although extensive construction was done throughout, it retained the Second Empire style of architecture originally designed. The post office moved to its new building between First and Walnut Streets in 1908, and the land office closed that same year, leaving just the federal court in this structure. (DMPL.)

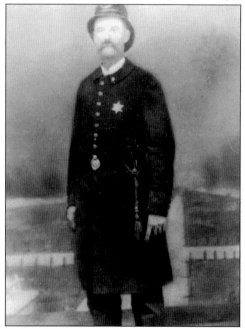

Joel Walker Miller served as a policeman for the city in the 1890s. With soldiers, sheriffs, and marshals keeping the peace during frontier times, the idea of having a separate police force was slow in coming to Des Moines. The first uniformed police were hired by the city to keep the peace during the Centennial Celebration on July 4, 1876. Often part-time, many early police officers continued to work in their trade. They would patrol from their homes, serving as guardians of their local neighborhoods. (DMPL.)

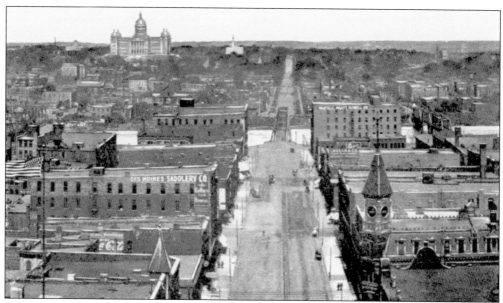

This bird's-eye view from the courthouse shows the capitol and Soldiers and Sailors Monument in the distance, the Saddlery Building on the left, the old Court Avenue bridge, and the Register and Leader building to the right. Though the bridge seems extremely narrow, it was still wide enough for trolley access. The 45-star flag visible here (used between 1896 and 1908) was flown from the top of the federal building just out of view. (HDM.)

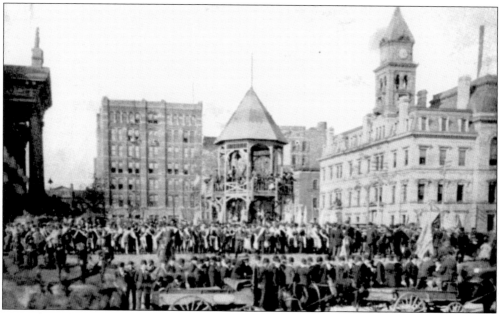

Festivals such as the Battle Flag Days and Carnival were opportunities for the city to come together and enjoy a bit of fun. In 1889, the annual Seni Om Sed celebration began. At first, the nightly celebration was tied to the Iowa State Fair (mostly an agricultural exhibition at the time), but soon the competition between the two caused Seni Om Sed to be moved to October. For a while, it was featured as the Mardi Gras of Iowa but never really established itself, dying out in the early 1920s. (HDM.)

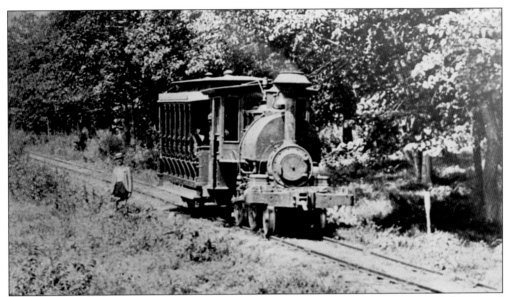

The first streetcar service appeared in 1866, built and managed by Dr. M. P. Turner, who owned a city charter for all horse-drawn trolleys. To get around the monopoly, H. E. Teachout formed a new company and began using steam trolleys such as this, which traveled the lengths of Ingersoll Avenue and Sycamore (now Grand) Street. As lines were extended out from the city center, development inevitably followed, and by the 1880s eight trolley suburbs surrounded Des Moines. (IDOT, Bob Krouse.)

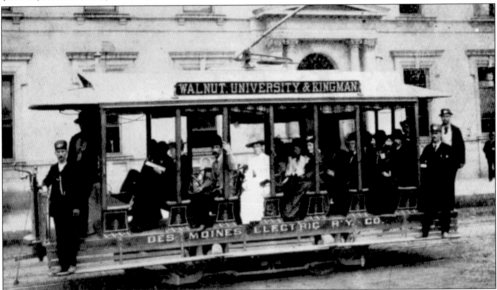

By 1886, three incompatible trolley lines were operating in Des Moines: Turner's original narrow-gauge and two other broad-gauge lines. What followed is referred to as the Great Trolley War, as all sides battled in court for the rights to service Des Moines. The supreme court eventually ruled in favor of the narrow-gauge line for horse-drawn trolley, but this just prompted the others to switch to steam and eventually electricity, such that, in 1888, Des Moines became the second city in the country (after Philadelphia) to inaugurate electric trolley service. J. S. Polk bought out his rivals and consolidated all trolley service under a new charter in 1895. (HDM.)

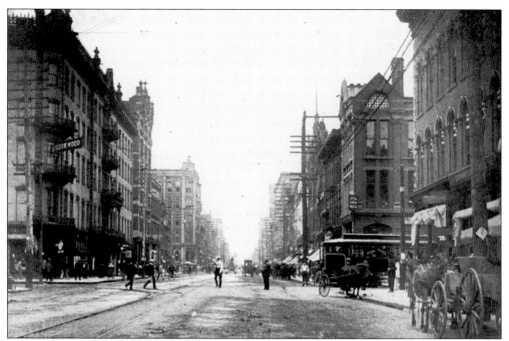

The city's growth can clearly be seen by comparing this late-1890s view down Walnut Street with that from the 1870s, as seen on page 19. The Savery has become the Kirkwood Hotel. Electrical and telephone lines balance precariously in stacks as much as 10 deep. The roads are still dirt, though packed; efforts to pave the streets using cedar board would prove a failure, and the city would begin brick paving after the dawn of the 20th century. (DMPL.)

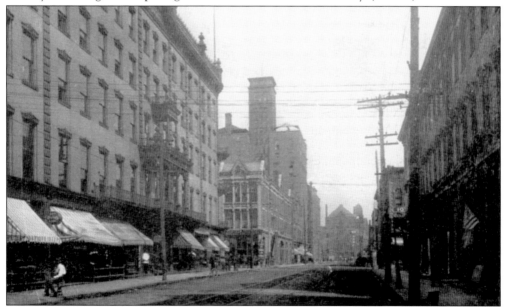

In this view from the Fourth Street side of the Kirkwood is the most prominent feature of Des Moines during this time: the Observatory Building, the tallest building in Iowa until the new Equitable Building was built in 1924. The structure with the dome and tower at the end of the block is the old YMCA. (HDM.)

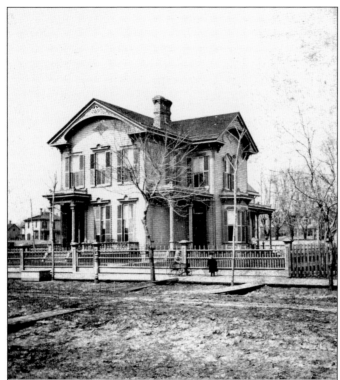

Hiram Y. Smith was an early pioneer lawyer who built this home at 1221 Sycamore (now Grand) Street in 1874 while serving as district attorney for the Fifth Judicial District. He continued his law practice and served in a number of public and private offices. His son Hirum Smith Jr. studied law at Drake University but instead pursued a career in real estate around the start of the 20th century. This lot is now part of the Iowa Medical Center. (DMPL.)

Another pioneer lawyer, Phineas M. Casady, lived at this house on Fifth Street and Chestnut Street (now Watson Powell Jr. Way). A district judge for many years, he was also involved in banking and other public service, eventually serving as president of Des Moines Bank. He married Augusta Grimmel, the daughter of Dr. F. C. Grimmel, in 1848. This site is now part of the Des Moines Capital Center complex. (DMPL.)

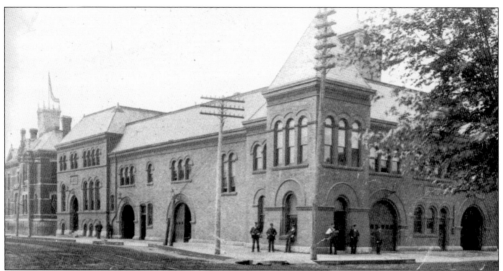

Before the 1880s, firefighting was mainly a volunteer enterprise in Des Moines. Three cisterns were built throughout the city, and hoses were strategically placed for easy access. After the Clapp Building fire in 1882 threatened to engulf the city, a paid fire department was established. The main station on the west side, pictured here, was located on Second Street and Grand Avenue. It later served as the central station for the city's police department as well. (DMIS.)

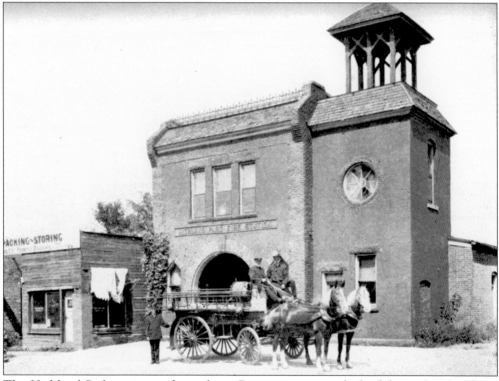

The Highland Park station is shown here. Because water supply for fighting fires had been an early priority, most firefighting equipment consisted of chemical pumps, hose wagons, and hook-and-ladder carts, all drawn by horses. (DMAR.)

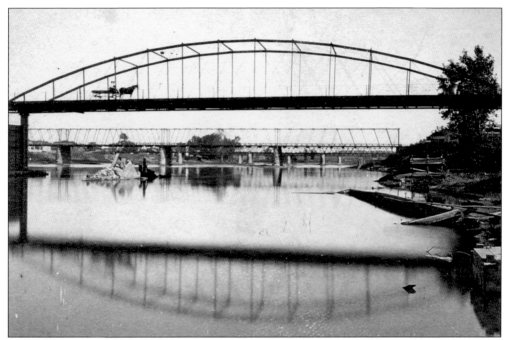

The Walnut Street iron bridge, built in 1871, replaced the earlier span of 1866. The earliest bridges in Des Moines were made of wood; they frequently washed out at high water, and were just as frequently replaced. Due to high maintenance costs, the city eventually began charging tolls to recover building expenses. (DMPL.)

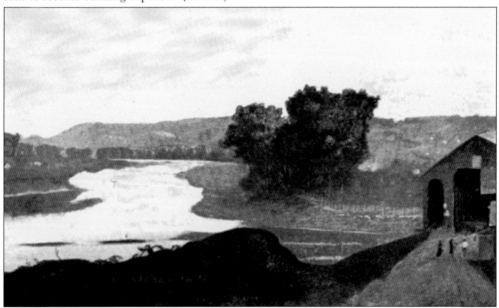

Based on a painting owned by Hoyt Sherman, this view of Raccoon Forks shows the covered bridge leading to Bloomfield Township, which was built as a free bridge by its residents. In 1871, a battle brewed over tolls the city enacted across all bridges; since a charge for crossing the Raccoon Forks span could not be levied, it was condemned by the city. A compromise was reached, and a new free bridge was built in its place. (HDM.)

Three

COMMERCIAL CENTER

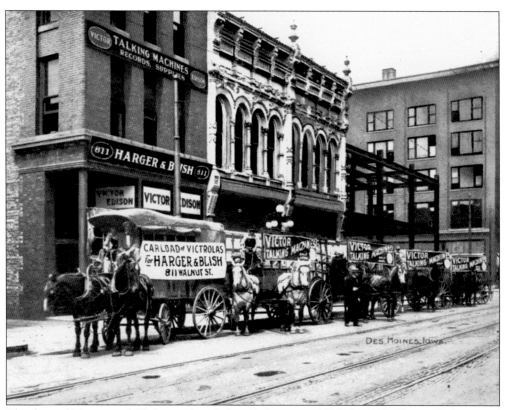

The firm of Harger and Blish was founded in Dubuque in 1888. In 1910, Henry Blish opened a branch office at 112 Eleventh Street, operating the store personally. He initially sold Edison Dictaphones, then moved on to radios and record players as the technology improved. This building was recently converted to condominiums as part of the Court Avenue redevelopment project. (DMB.)

This view of Des Moines shows many of the significant buildings and attractions of the 1870s, including all of the schoolhouses, many prominent residences, the bridge and rail lines crossing the city, and several business locations. The capitol as shown did not actually exist in 1875 when this map was published, as it still needed much construction at the time. (Atlas.)

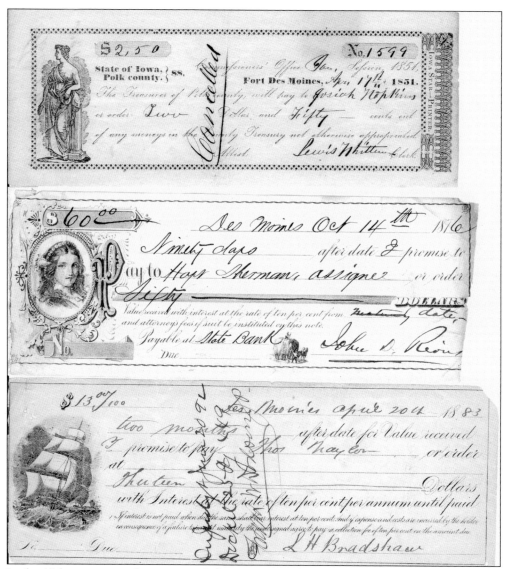

In the 19th century, credit was extended to customers through vouchers and promissory notes, negotiated solely on the reputation of the borrower and the terms of the creditor. Often these notes were used in the sale of furniture or other expensive items for which there was a need. Unfortunately, many of these notes went into judgment; every one had to be collected through court action.

The Youngerman Block at Fifth and Mulberry Streets (which eventually became the site of the Penny's building, and is now a medical documents office) is just one representation of the work of Conrad Youngerman. He constructed many of the blocks, houses of worship, and other buildings in the downtown district of early Des Moines. (DMB.)

The Clapp Block, where the Citizens National Bank operated, was built at the southwest corner of Fifth and Walnut Streets in 1873 by Edwin Clapp, a former ferryman, stockyard broker, and clerk. In 1882, the block caught fire, but the bank was still able to open the next day. It was completely remodeled in 1890, with a new floor added and the first elevator in the city installed. (DMB.)

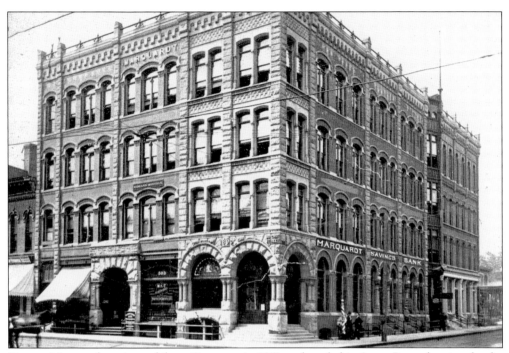

George Marquardt emigrated from Germany in 1852 and settled in Iowa. By trade a jeweler, he founded a wholesale jewelry and watchmaking company, which was widely successful. His early interest in real estate led to other successes, and he built this block at the northwest corner of Fifth and Locust Streets in 1901. He also served as president of Marquardt Savings Bank. (DMB.)

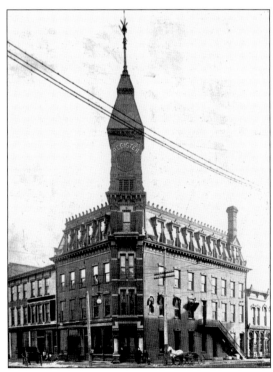

This building is the home of the *Iowa State Register*, one of several newspapers published in Des Moines. The *Register* merged with the *Leader* in 1903, an act that combined the two largest morning papers in the city. This was followed by the purchase of the *Evening Tribune*. By 1910, only two other papers were competing with the *Register*: the *Daily Capital* and the *Daily News*, which had the distinction of being the first penny newspaper in the country. (DMIS.)

Not only did Dr. Turner lead in community services, but he also built several blocks in the downtown area, including this one on the southwest corner of Seventh Street and Sycamore (now Grand) Street, first occupied by the Studebaker Carriage Company. After a significant expansion, it then served as the home of the Des Moines Life Insurance Company. (DMIS.)

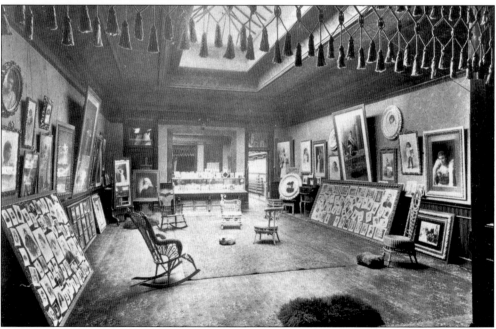

Thomas James's Art Palace, at 319 Walnut Street, was a typical artist's studio. Painted portraits were still in vogue in the 1890s, although photography had been making inroads for decades. Often, as can be seen here, portraits were already being painted from photographs, rather than through time-consuming sittings. (DMIS.)

The Younker Brothers dry goods store was built at Seventh and Walnut Streets in 1899, with an extensive addition constructed in 1909. Lytton, Samuel, and Marcus Younker founded their firm in Keokuk in 1856. They established a branch in Des Moines in 1874 and eventually relocated their headquarters to this city. Their younger brother, Herman, and Samuel's son Aaron headed up the business when it incorporated in 1904. (HDM.)

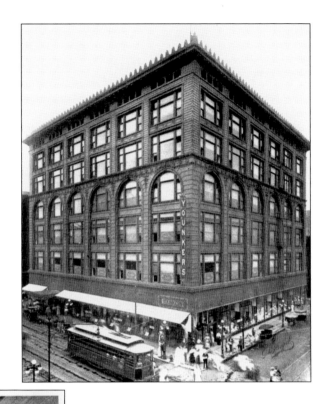

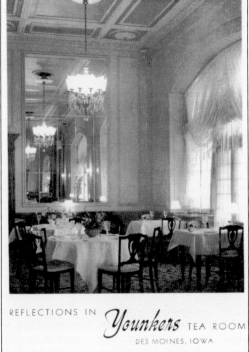

REFLECTIONS IN *Younkers* TEA ROOM
DES MOINES, IOWA

Where you meet your friends and enjoy good food

Opening in 1913 on the fifth floor of the department store, the Younkers Tea Room provided an elegant dining environment with its parquet floors, arched windows, and ornate architecture. It remained in operation until 2005, when the downtown Younkers building was closed. The department store chain currently operates 47 stores in seven states.

In Consideration of the IOWA INDUSTRIAL EXPOSITION COMPANY erecting a suitable building for Exhibition purposes, covering not less than TEN THOUSAND Square Feet upon the ground, said ground to be selected within five blocks of the intersection of Walnut with Fifth Street, Des Moines, and assigning to *me Fifty* Square Feet of floor room therein to be used for the purpose of EXHIBITING and ADVERTISING such articles as *I* may desire to, subject to the Rules and Regulations of above named Company, for the term of *One Year* from and after the completion of said building, *I* agree to pay the sum of *One Hundred* DOLLARS, to the Iowa Industrial Exposition Company, or order *Fifty* Dollars, when said building is enclosed *Fifty* Dollars, when said building is formally opened for the uses for which it is to be erected.

Des Moines, Iowa, *Dec 2 1875*

MILLS & CO., PRINTERS, DES MOINES, IOWA.

The Iowa Exhibition Building, constructed in 1876 at the southwest corner of Eighth and Walnut Streets (now an insurance building), was originally intended to display the Iowa Centennial Exhibition that was then in Philadelphia. While it did serve as an exhibition hall for some time, it was eventually sold to business interests. (CHDM.)

The proprietor of the Iliad Hotel bought the former Exhibition Hall and added two floors, creating the space he needed to expand his business. Nevertheless, the Iliad also went bankrupt, and the space then became the Grand (later the Harris-Emery) department store, until that store's merger with Younkers in 1927. (DMIS.)

The old Savery Hotel was refurbished and renamed the Kirkwood in 1878, though the name change did not sit well with many of the pioneers of the city, who continued to refer to it as the Old Savery. Still, it was a well-respected establishment. This building caught fire on April 6, 1929, and was demolished to make way for a new Kirkwood Hotel. (DMIS.)

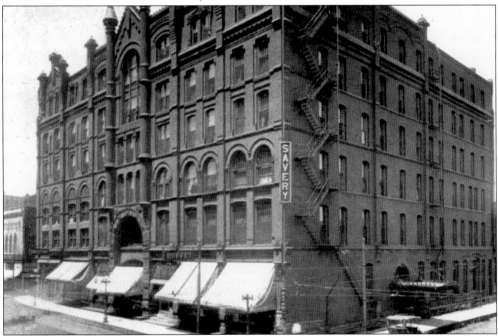

In 1886, a group of businessmen decided that Des Moines needed a new hotel to service their clients. In tribute to the Old Savery, the group chose to name this new hotel after the original. James Savery had only a passing investment in the hotel's charter; rather than profit, he treasured the esteem of the business community in their choice of name for the establishment. Located on the northwest corner of Fourth and Locust Streets, this building was torn down in 1919 to allow for the third Savery Hotel. (HDM.)

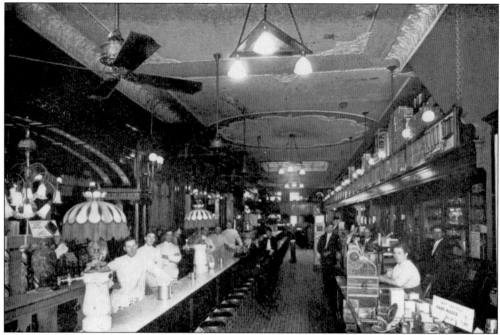

Charles Namur worked at the Rogg Drug Company before opening his own drugstore. In 1904, he bought out his partner and moved to 617 Walnut Street, where he claimed to have the largest soda fountain in the country. Namur was also involved in other profitable entertainment ventures. (DMB.)

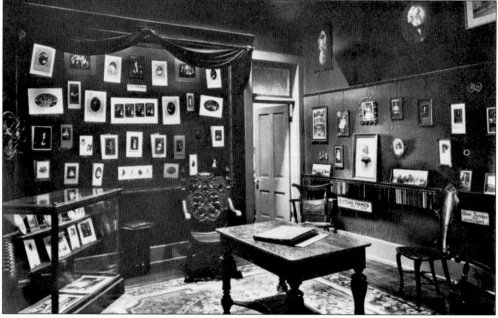

Albert Harpel worked out of this studio at 514 East Locust Street. He and other photographers, such as F. Wolcott Webster at 312 Sixth Avenue, provided a service to history by taking many photographs of Des Moines and the surrounding area, several of which are featured in this collection. (DMB.)

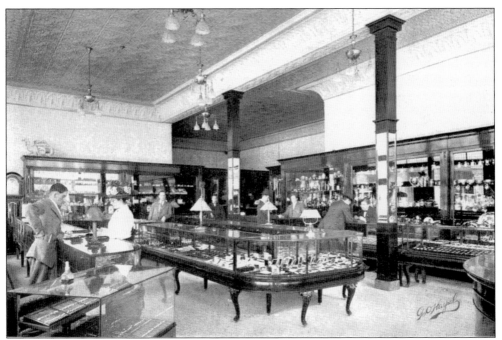

Frank Schlampp partnered with Fred H. Curl to form Curl and Schlampp Jewelry at the corner of Sixth and Locust Streets. Later buying out his partner, he purchased an exquisite Seth Thomas clock tower in 1906 and placed it on the corner to advertise his store. (DMB.)

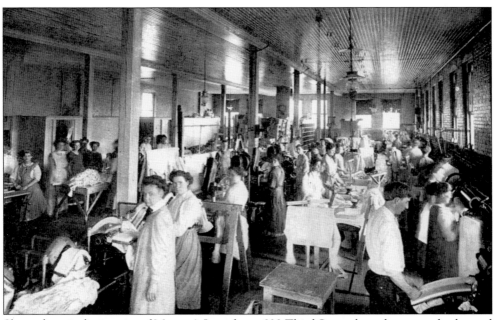

Shown here is the interior of Munger's Laundry at 220 Third Street; branches were also located on Mulberry Street and Grand Avenue. The firm's specialty was lace curtains, which needed the most delicate care. The petroleum-based dry-cleaning solutions used during this time were highly flammable and toxic. After World War I, nonflammable and safer chlorinated solvents were used in the process. (DMB.)

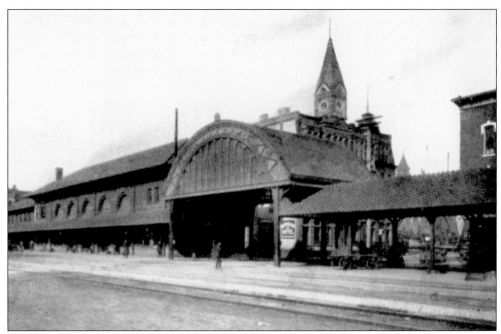

The Des Moines Valley Railroad completed work on the line between Keokuk and Des Moines in 1866, finally opening up the city to regular travel and commerce. Although there was now steady traffic to the capital city, the railroad struggled and was eventually purchased by the Chicago, Rock Island, and Pacific in 1878. As other rail systems were acquired, the Rock Island, as it came to be called, built this depot on Vine Street between Third and Fourth Streets. (DMB.)

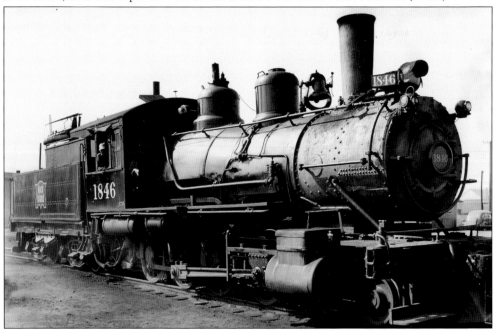

The 2-8-0 Consolidation engine, first produced in 1875, became the workhorse of many railroads in the late 19th century. This one, owned by the Rock Island Railroad, is in the process of switching loads before heading west. (Courtesy R. D. Kimmel.)

DES MOINES

—AND—

MINNESOTA RAILROAD.

NARROW GAUGE.

——o——

THREE FIRST CLASS TRAINS EACH WAY DAILY

BETWEEN

DES MOINES

—AND—

AMES.

——o——

Connections close and certain with all Passenger Trains on the C. & N. W. R'y.
Passengers for DES MOINES, and all points South, can leave—

DAY TRAIN.	NIGHT TRAIN.
Clinton, 5:30 A. M.	Clinton, 4:35 P. M.
Cedar Rapids, 9:40 A. M.	Cedar Rapids, 8:40 P. M.
Marshalltown, 1:10 P. M.	Marshalltown, 11:55 P. M.
Missouri Valley Junction, 7:28 A. M.	Missouri Valley Junction, 6:22 P. M.
Grand Junction, 12:47 P. M.	Grand Junction, 11:10 P. M.
Ames, 3:15 P. M.	Ames, 2:00 A. M.
Arrive at Des Moines, 5:30 P. M.	Arrive at Des Moines, 4:00 A. M.

Ames Accommodation leaves Ames at 8:00 A. M.

Trains leave Des Moines—Mail and Express, 12:30 P. M.; Ames Accommodation, 4:00 P. M.; Night Express, 10:30 P. M.

Connections at Des Moines.

C., R. I. & P. R. R., East, West and Southwest.
Keokuk & Des Moines R. R. for Ottumwa, Keokuk, St. Louis, and all points South and Southwest.

J. J. SMART, Gen'l Supt.

358

At one time, 11 different railroads operated in or through Des Moines. Most of these were founded in cities such as Chicago, St. Louis, or Minneapolis. One particular company, though, was founded in this city: the Des Moines and Minnesota. To save money, it was built as a narrow-gauge rail line, and went as far as Ames. Nevertheless, the company was eventually absorbed into the Chicago and Northwestern, which relaid the road as standard gauge. (CHDM.)

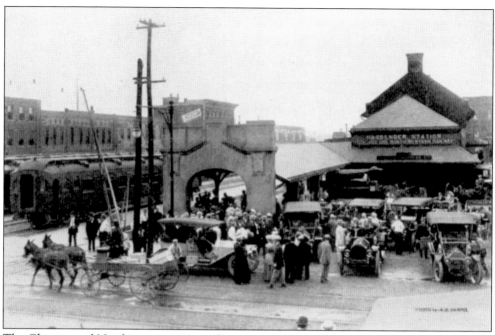

The Chicago and Northwestern was another victor in the railroad wars, eventually swallowing up other lines besides the Des Moines and Minnesota. The company built this station on East Fourth Street between Walnut and Locust Streets, providing the east side with its main access to railway service. (DMB.)

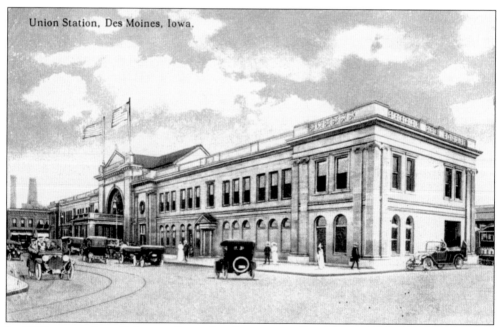

In 1884, a number of the smaller railroads servicing Des Moines joined with the Union Pacific to compete with the larger outfits. Largely providing regional service in Iowa along the St. Louis lines, the Union depot at Fifth and Cherry Streets proved to be quite successful, as it was situated next to the Polk County Courthouse. (DMB.)

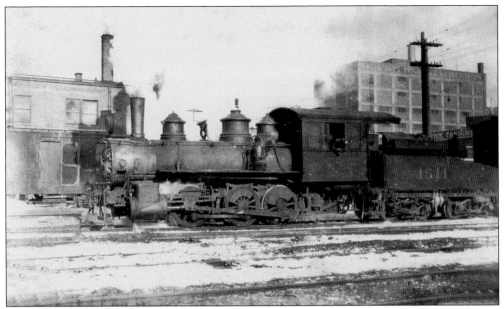

This 0-6-0 Six-Coupled tank engine was used as a switcher in the rail yards south of the capitol. With no leading or trailing guide wheels, engines of this type were powerful, although unsuited for long runs due to instability at high speeds. However, they were sometimes used to run heavy freight like coal to neighboring communities. (DMPL.)

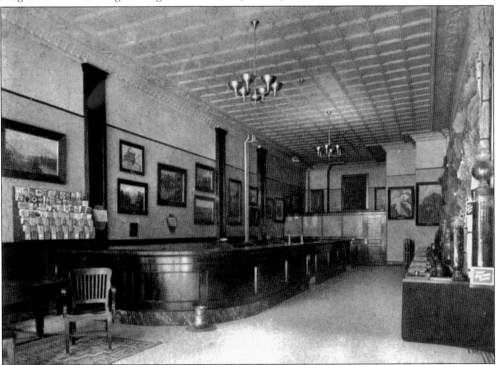

The Atchison, Topeka, and Santa Fe also had a presence in Des Moines for a number of years, although it mainly used lines leased by other railroads. Tickets and transfers could be purchased at its offices in the old Equitable Building. (DMB.)

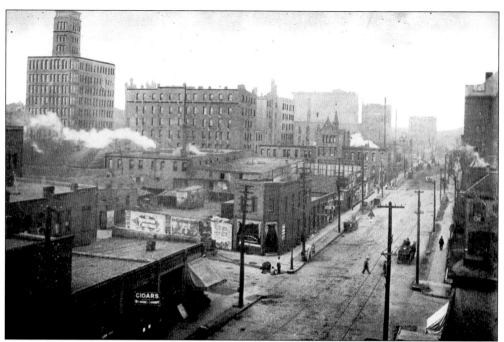

This view, taken from the corner of Third Street and Grand Avenue in 1902, shows the business section of downtown. Visible are the Observatory Building, the Savery Hotel, the old Equitable Building, and just south of Grand Avenue, the Des Moines Life Insurance building, among other businesses. (DMPL.)

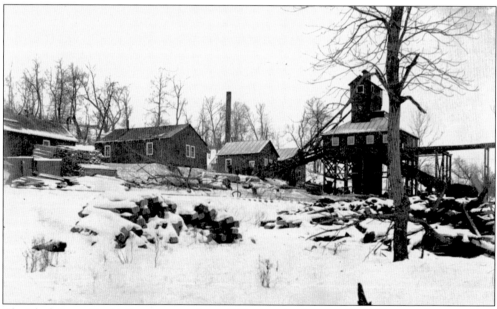

The Black Swan Coal Mine was one of over 220 mines in the area. By 1910, more than a million tons of coal per year were mined within the Des Moines city limits, mostly along the Des Moines River and on the east side. The coal was mainly used to power steam locomotives, and its need diminished after the industry turned to diesel. The last coal mine closed in 1947, but subsistence of undermined soil is still a problem in some parts of the city. (DMIS.)

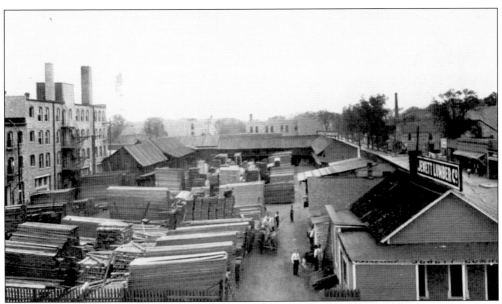

Located on Ninth Street and Grand Avenue, the Jewett Lumber Company made use of the Des Moines and Raccoon Rivers' abundant timber for manufacturing lumber, which was critical to building efforts as the city expanded. Later, as supplies dwindled, lumberyards became little more than wholesalers and storage for lumber manufactured in Wisconsin and Minnesota. (DMB.)

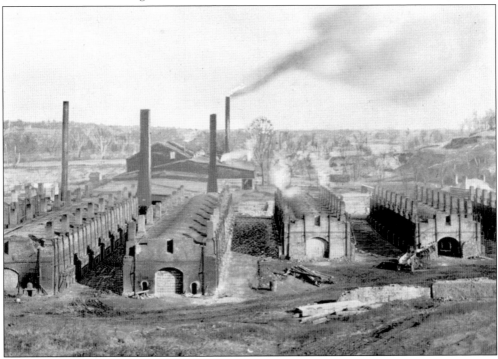

The Iowa Brick Yard, like many other brick and tile companies, depended on outcrops of clay shale found along many points of the Des Moines River. A kind of brick known as Beaverdale became the source for a unique style of construction. Miles of tile bricks were used in the late 19th century to create drainage for upper Iowa wetlands being converted to farmland. (DMIS.)

The Des Moines Electric Company based its operations out of the Youngerman Block, across from the east yard of the courthouse, and provided power to the trolley system, to the street lighting that was being installed in the downtown area, and to many of the businesses requiring connection. However, electricity was not a universal commodity for residents until later. (HDM.)

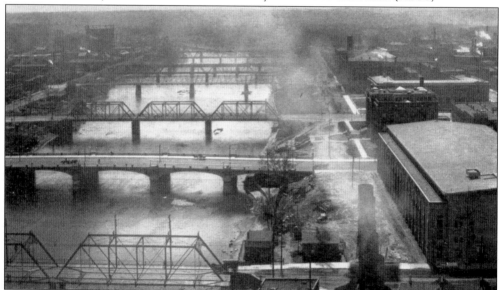

This view was taken from the Des Moines Power Company building, which was located along the Des Moines River just north of the new civic center. Like most power plants, this one burned coal to generate electricity. Pollution was such a problem in Des Moines that when James D. Edmundson created an endowment for what became the Des Moines Art Center, he stipulated that the museum could not be located east of West Fourteenth Street because of the constant smoke in the air downtown. (DMAR.)

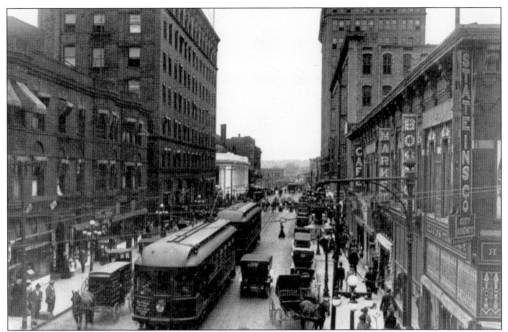

This photograph of Sixth Street shows the old Citizens National Bank building on the left and the Fleming Building (which still stands today) on the right. Other shops include Higgen's Pharmacy, the State Insurance Company, and Boston Market, which had the first large-scale refrigeration units installed near the end of the 19th century. (HDM.)

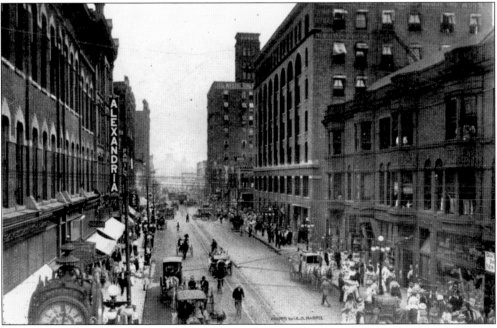

The theater district in Des Moines was centered on Locust Street between Fifth and Seventh Streets. In addition to the Alexandria, the Family, Casino, and Palace Theatres were operating. Nearby the Alexandria are the Clapp Building and the Observatory tower, and in the lower part of the image, Schlampp's clock tower is visible on the corner. (HDM.)

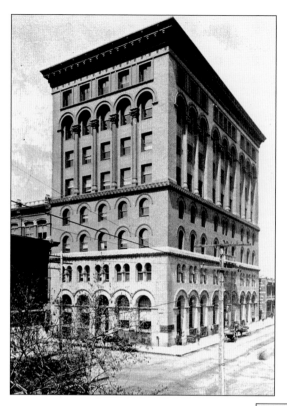

The old Equitable Life Assurance Building, at Sixth and Locust Streets, was constructed in 1891 in a Romanesque style and was expanded in 1911 with four additional floors. Later purchased by Banker's Trust, the building was briefly on the National Register of Historic Places. When Ruan Corporation purchased Banker's Trust, it tried to interest potential tenants in the complex. Preservation groups fought to save the structure in the 1970s; nevertheless, it lay vacant for years and was finally demolished in 1978. (DMIS.)

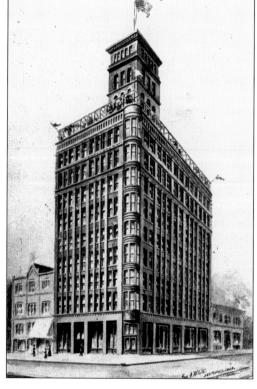

The Van Ginkel Building was constructed at Fourth and Locust Streets in 1895 as Des Moines's first skyscraper. It was later known as the Observatory Building due to the view available from its five-story tower. Many residents feared that its height would prevent firefighters from stopping a blaze. The structure had trouble retaining tenants and was eventually torn down in 1937. The site is now home to the Capitol Square Mall. (DMIS.)

Four

EDUCATION

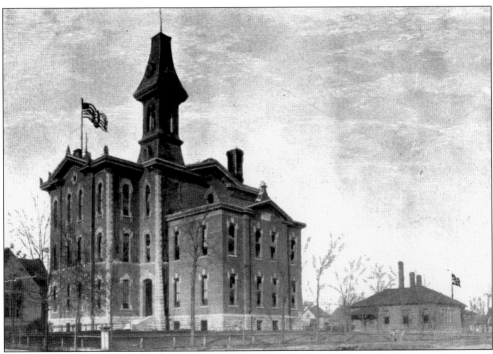

Webster and Alcott Schools, which stood on Lyon Street between East Twelfth and Thirteenth Streets (now the location of Mercy Medical Center), provided primary education to boys and girls, though separately for a time. The schools were part of the East Des Moines District, which operated autonomously until 1907. Founded in 1874, the school lasted until 1963, when it was closed due to freeway construction. (DMIS.)

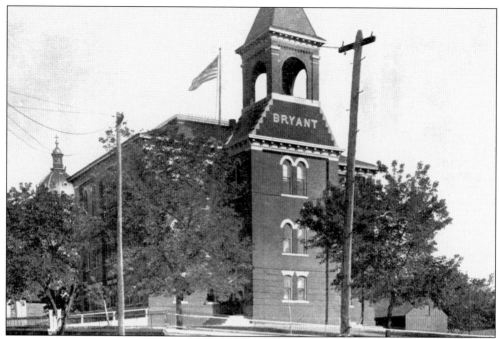

In 1867, the east side's first school was constructed on Pennsylvania and Sycamore (now Grand) Street. It did not have a name until 1880, when it was named after the poet William Cullen Bryant. It was considered the finest and best-built schoolhouse in western Iowa when it opened. The building survived until the 1960s, when it too was razed to allow for the Des Moines Freeway. (DMIS.)

Originally called the Fourth Ward Schoolhouse, Crocker School was built at Sixth and School Streets in the West Des Moines District in 1863. A single teacher in this building taught the high school until it was moved to Lincoln School. Crocker was also demolished due to freeway construction in 1963. (DMB.)

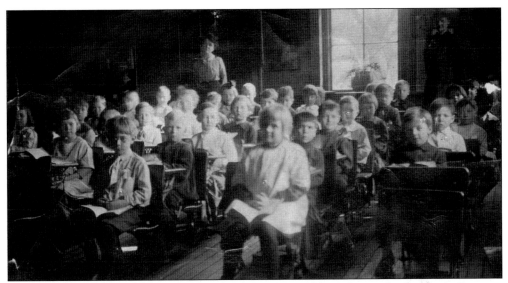

This class photograph was likely taken at Benton School, located near the Southeast Bottoms area on East Twelfth and Shaw Streets, near the packing house. The Bottoms was a very poor area, filled with railway traffic and prone to flooding. The Des Moines School District thankfully had a solid commitment to educate even the poorest people of the city. (DMPL.)

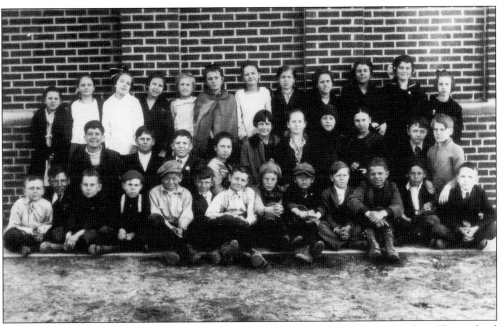

These children, in first through eighth grades, attended Stowe Elementary School on Thirty-third Street and Cleveland Avenue between 1915 and 1920, meeting in one of two classrooms. The original Stowe School was located at Twenty-ninth Street and Guthrie Avenue, but it burned down in a fire in 1914. This building was constructed as a single-story two-room schoolhouse, but two other floors (also two-room) were added in 1917. The school continued to expand and, as of 2006, has 370 students enrolled. (DMPL.)

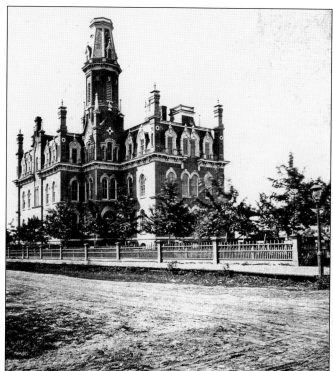

Lincoln School offered both primary and secondary education until 1888, when West Des Moines High School was built. Located on Ninth and Mulberry Streets, Lincoln School was built in 1867 and closed before 1923, when construction began on Lincoln High School at Ninth Street and Bell Avenue. (DMPL.)

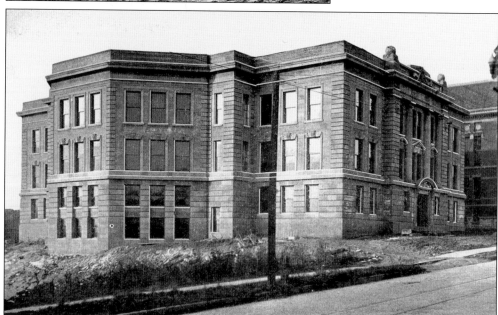

West Des Moines High School was built at Fifteenth and Center Streets (now the site of Iowa Methodist Hospital) in 1888. Until this time, secondary studies had been conducted on the upper floor of the Lincoln School. The curriculum offered tracks in English, reading, science, business, Latin, and college-preparatory classical studies. Most of the students moved to Roosevelt High in 1923. The building later became the Technical High School in 1942 but was abandoned in 1952 when the Technical High School moved to the former Solar Aircraft building. (DMB.)

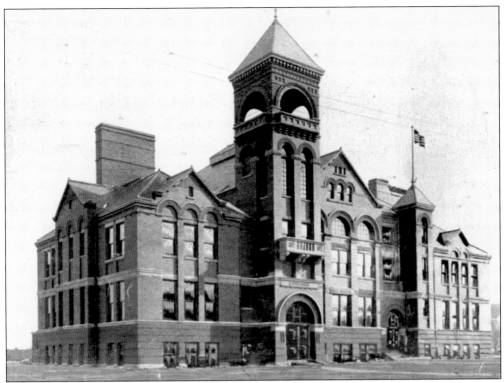

North Des Moines High School was originally situated in a suburb of Des Moines until the city's expansion in 1890. A survey taken during this time showed that less than 10 percent of 14-year-old boys were attending school. The North Des Moines School District retained its autonomy until the consolidation of school districts in 1907; when this took place, 35 students from Oak Park High were transferred. By 1915, enrollment was so high that larger facilities needed to be constructed. This facility was abandoned in 1958, replaced by the "new" North High School. (DMIS.)

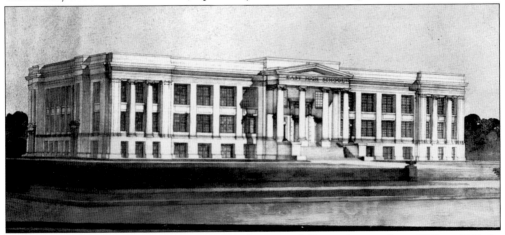

The first East High School stood at Twelfth Street and Court Avenue from 1891 to 1911. In only 10 years, enrollment exploded from 200 to 700 students, which necessitated a new facility. Construction began in 1911 at Thirteenth and Walker Streets, with the school opening on May 17, 1912. Because no funds were available to furnish the new school, the entire student body helped transport desks, chairs, books, and other equipment from the old building. (DMB.)

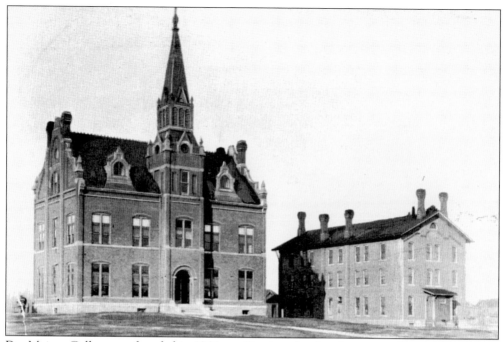

Des Moines College was founded in 1864 as a Baptist school and seminary. It moved to its new campus on College Avenue and Ninth Street (now a correctional facility) in 1884. Suffering financial difficulties, it merged with Central and Highland Park Colleges to become Des Moines University. (DMB.)

A group of businessmen, eager to bring higher education into the city, established Highland Park College. Opening its doors at the corner of Euclid Avenue and Second Street (now the Park Fair Mall) in 1889, it offered a year's worth of free tuition as an incentive to students. After the merger, Des Moines University continued to struggle and eventually closed in 1929. The current Des Moines University was originally the Still College of Osteopathy, founded in 1898. (DMPL.)

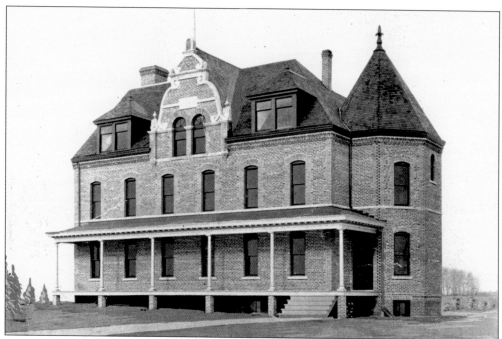

In 1895, Grand View College was founded as a school and seminary for the Danish Lutheran Church. Though small, it steadily continued to enroll students, mostly Danish, for ministerial and professional education. The college began its first four-year program of study in 1975. (DMIS.)

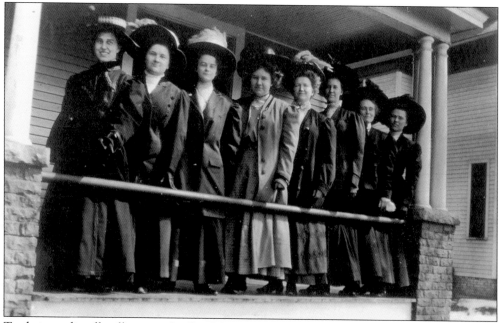

To their credit, all colleges in the Des Moines area were coeducational, as evidenced by this postcard sent by Rena McIntyre to her family in April 1909. It depicts her sorority sisters. McIntyre reports that the nice weather is discouraging her studying, that her tuition next term will be $11, and that she has broken her bike, requiring $1 in repairs.

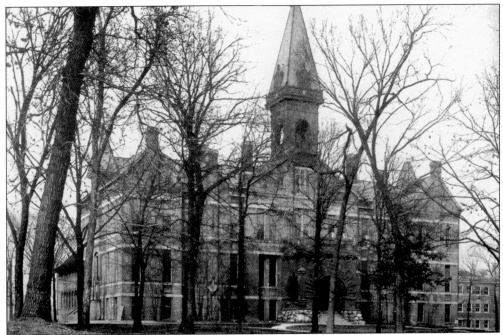

Drake University was established in 1881 by George Carpenter, who brought with him most of the students and almost the entire faculty of Oskaloosa College, a struggling school founded by the Disciples of Christ. At the time, northwest Des Moines was a wilderness, with little access to public transportation. Gen. Francis Marion Drake, Dr. Carpenter's brother-in-law, funded much of the early development of the campus through his personal fortune. (DMPL.)

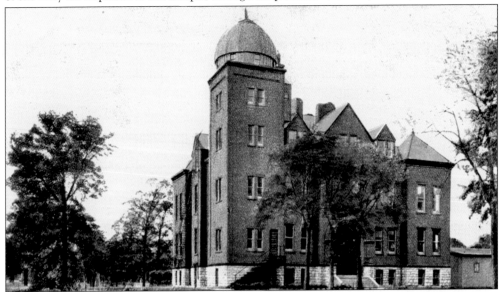

In 1893, Drake University's Science Hall was built, featuring a rooftop observatory with an eight-and-one-half-inch refracting telescope donated to the university by its financial backer, Gen. Francis Marion Drake. The building slowly began to decay and was eventually torn down in 1949. In other venues, the college was highly successful; it had established a law school, a medical and pharmacy college, and a school of dentistry—all by 1900.

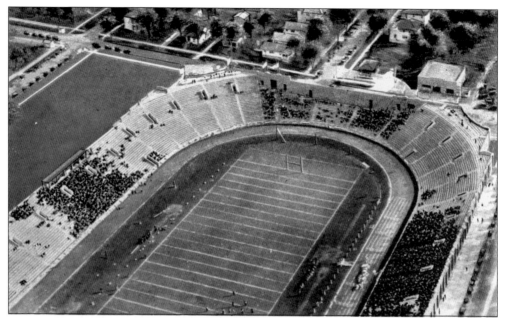

Drake Stadium sponsored a solid physical education program that included football and other field sports. In 1910, a regional track meet led to what has become an international competition. The Drake Relays, held every spring since that time, bring thousands of participants and spectators every year to Des Moines.

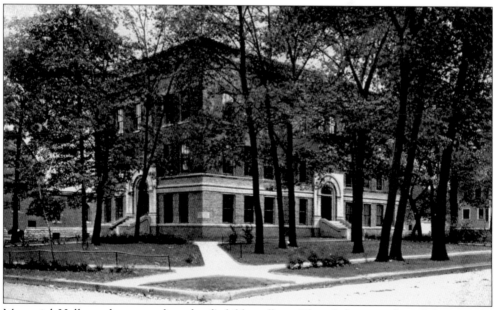

Memorial Hall was home to the school's bible college. Though bearing the solid roots of a denominational school, Drake University from the beginning opened its doors to anyone regardless of race, religion, or gender.

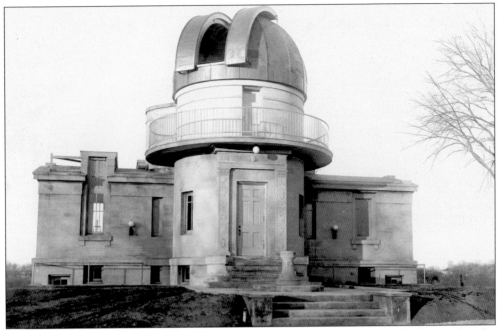

The new Drake Observatory in Waveland Park was built in 1920 on the highest ground in the city. It contains the same telescope Francis Drake donated to the school in 1894. The observatory is still operated jointly by the City of Des Moines and Drake University and frequently has public shows. (DMPL.)

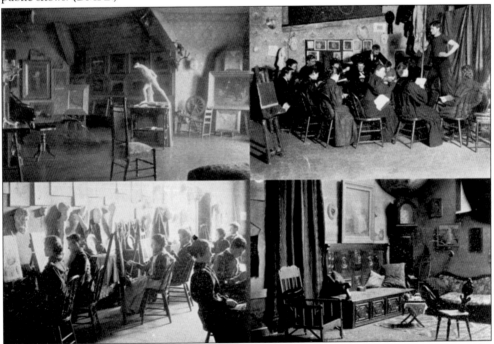

Founded by Charles Cumming in 1895, the Des Moines School of Art eventually took over the top floor of the new library building. The rent for his school was paid to the city through the offering of six free scholarships to promising students from Des Moines. (DMIS.)

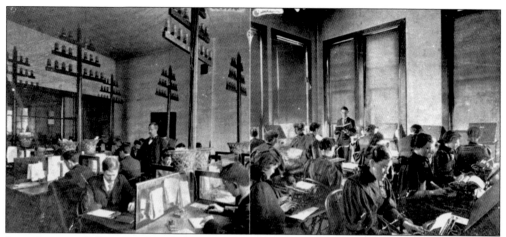

Iowa Business College was founded in 1865 at the corner of Walnut and Fourth Streets by J. W. Muffly and C. B. Worthington as one of the chain of Worthington's colleges. It passed into the control of A. C. Jennings in 1875, who relocated it to Fourth and Locust Streets. The college featured instruction in telegraphy, typing, and the principles of banking and exchange. (DMIS.)

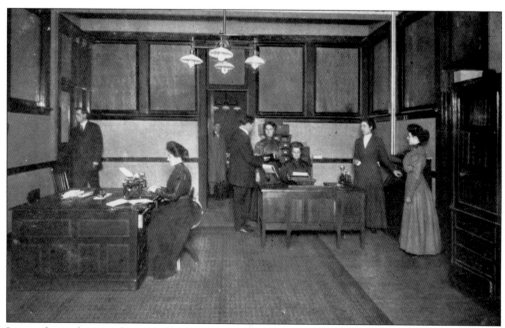

Located on the top floor of the YMCA at Fourth Street and Grand Avenue, Capital City Commercial College provided a two-year curriculum of study, emphasizing shorthand, typing, and commercial studies. In 1910, the enrollment was 796 students.

The Des Moines Public Library initially served as a solely private library organization in 1866, and operated as such for many years, before becoming public in 1882. Though a popular institution, it struggled for many years and moved from place to place; located first in the Register building, it moved to the Youngerman building, then to the YMCA. In 1895, the library moved to the Rogg Building on Eighth and Locust Streets, where these photographs were taken. (DMIS.)

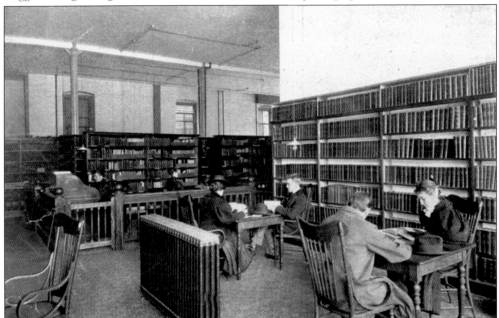

Shown here are the library's reference room and office. It also had a book room, reading room, and delivery counter. In 1903, preparations were underway to construct a new and permanent facility on the Des Moines River, on the former site of General Crocker's home. (DMIS.)

Five

HEARTLAND

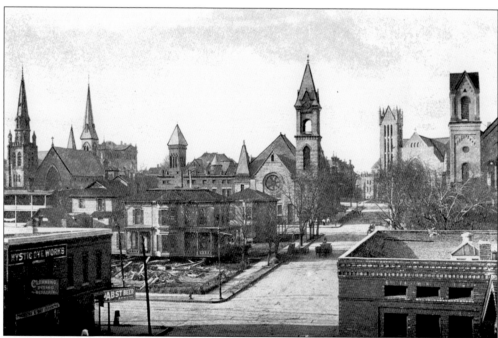

One of the more recognizable landmarks in Des Moines was Piety Hill, where the steeples of seven houses of worship could be seen: (from left to right) St. Paul's Episcopal, First Methodist, Central Church of Christ, First Baptist, Yeshurun Temple, Plymouth Congregational, and Central Presbyterian. Unfortunately, with the progress of time and the growth of the city, most of these facilities were relocated. (DMPL.)

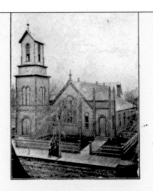

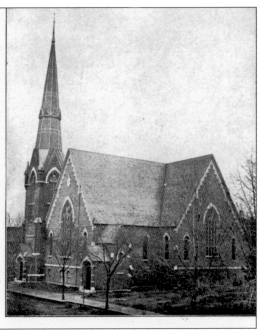

PLYMOUTH CONGREGATIONAL CHURCH,

CORNER SEVENTH AND LOCUST STREETS, DES MOINES, IOWA.

Issued Oct. 2, 1896, in Commemoration of the 25th Anniversary of the Pastorate of Rev. A. L. Frisbie, D. D.

THE OLD CHURCH *Erected on Court Avenue, near Fifth Street, in 1858; afterwards removed to the lot east of the present church and repaired and enlarged; occupied for the last time September 10, 1876.*

THE PRESENT CHURCH *Erected in fall and early winter of 1876-7; dedicated September 14, 1877. (The engraving herewith is from a photograph taken shortly after the church's completion.)*

Plymouth Congregational was founded by pioneer minister Thompson Bird in 1857. This invitation card, issued for the celebration of the silver anniversary of pastor Reverend Frisbee, shows both the old and new church buildings (the latter now the location of the Ruan Building at Seventh and Locust Streets). The congregation later moved to Eighth and Pleasant Streets (as seen on the previous page) and then again when that building was razed for the widening of Keosaugua Way. The church now meets at Forty-second Street and Ingersoll Avenue. (DMPL.)

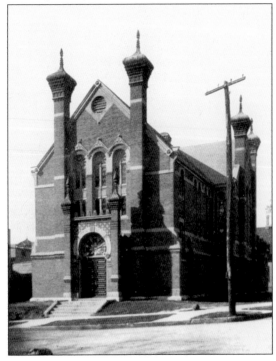

A Jewish community was present in Des Moines almost from the beginning, but the first formal congregation did not appear until 1873. Temple B'Nai Yeshurun, pictured here, was built across from the Congregational church in 1875. By 1885, many of the conservative members had left to form B'Nai Israel (now Tifereth Israel), while the Orthodox had formed Beth El Jacob. (DMPL.)

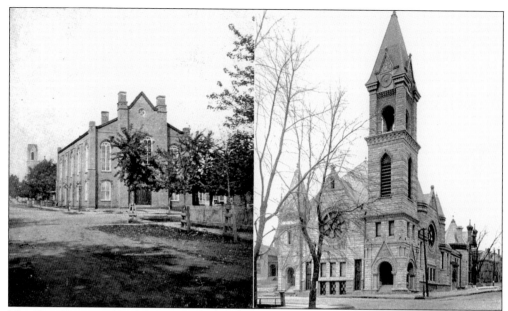

The First Baptist Church was founded in 1850. This church (right), the congregation's third, was built on Eighth and High Streets in 1894 after the second building, on Eighth and Locust Streets (left), was declared unsafe. The congregation remained at this location for over 100 years, remodeling and rebuilding as needed, until it relocated to the Des Moines suburb of Johnson in 2002. Church rebuilding was actually fairly common as congregations outgrew their facilities and the city center grew up around them. (DMPL, DMIS.)

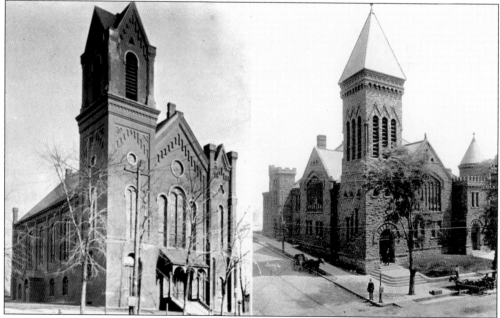

Central Presbyterian moved into this facility (left) on Eighth and High Streets after the merging of its New School congregation with that of First Presbyterian's Old School ministry. Central Church of Christ (right), organized through the efforts of circuit riders, purchased the old Presbyterian church on Seventh and Locust Streets as its ministry expanded. (DMIS.)

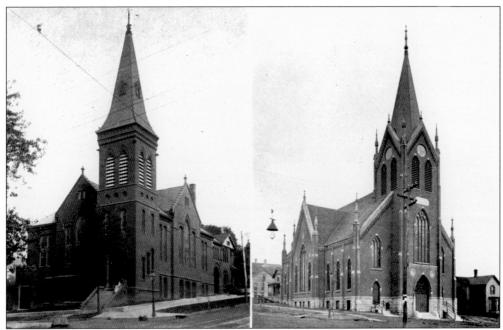

St. John's Lutheran Church was established in 1865 after several halting efforts, including a failed school at the site of Des Moines College. The church constructed this building on Chestnut and Sixth Streets in 1892. The Swedish Lutheran Church (right) was built in 1886 at the corner of East Fifth and Des Moines Streets. Other congregations from Germany, Denmark, and Norway also existed at the time. (DMIS.)

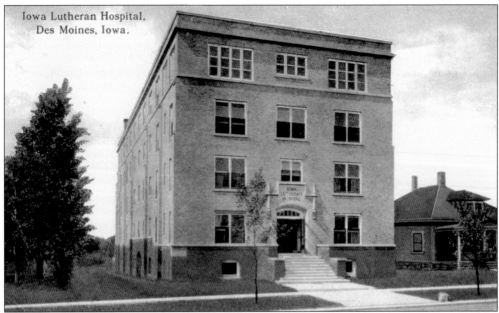

Lutheran Hospital was founded in 1914 by the Swedish Lutheran Church, along with its school of nursing, as an outgrowth of a medical auxiliary outreach program begun in 1910. It quickly developed a reputation for innovation, obtaining firsts in a number of research areas such as polio, dialysis, and multiple sclerosis.

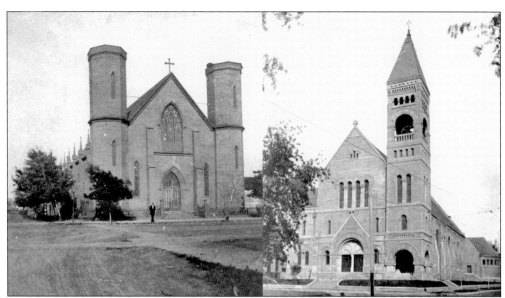

In 1856, St. Ambrose Cathedral was founded at Sixth and Locust Streets; the brick building shown here (left) was built in 1864. Irish immigration to the city expanded the membership considerably, and the cathedral was rebuilt in stone on Sixth and High Streets (right) at the end of the 19th century, with additional living quarters for the resident priests. (DMPL, DMIS.)

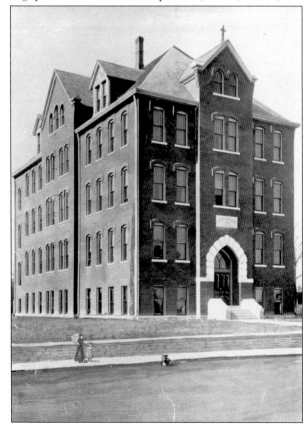

Mercy Hospital was founded in 1893 on Fourth and Ascension Streets by the Sisters of Mercy, who came from Davenport. It eventually became the largest hospital in Iowa and the center of a statewide medical care organization. The facility continues its not-for-profit status to this day, with a steadfast commitment to the poor and uninsured. (DMIS.)

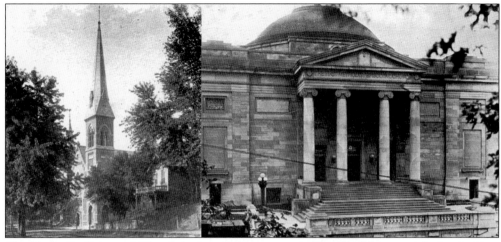

The Methodist Episcopal Church had an early presence in Fort Des Moines, with circuit riders such as Ezra Rathbun providing needed pastoral care at the stockade. Several church buildings were erected throughout the city; eventually two such congregations merged and located their facility here, at Ninth and Pleasant Streets (left). This building remained for several years, but was eventually replaced by the current facility facing Tenth Street (right). (DMIS, HDM.)

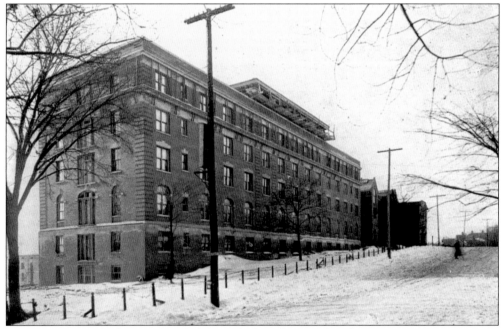

In 1901, Iowa Methodist was founded through the efforts of that denomination's caregivers, as an offshoot of its own nursing school. The facility established strong programs in cancer and heart disease treatment. In 1993, Iowa Methodist, Iowa Lutheran, and Blank Children's Hospital merged to form Iowa Health, the largest health care system in the state. (HDM.)

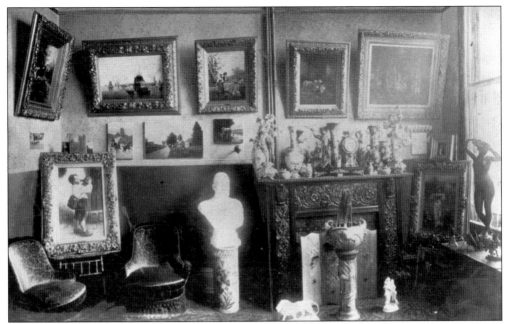

Until the start of the 20th century, most doctors in Des Moines were private practice. Dr. Joseph Cannon's office, situated at 520 Walnut Street, featured Galvanic, Faradic, and Static treatments for muscle tension. His reception room, pictured here, displayed a number of artworks for his patrons to view. The Polk County Medical Society has met regularly since 1858 to coordinate and regulate medical practices within the county and, since 1870, has operated Cottage Hospital, which was the only one in the city for over 20 years. (DMIS.)

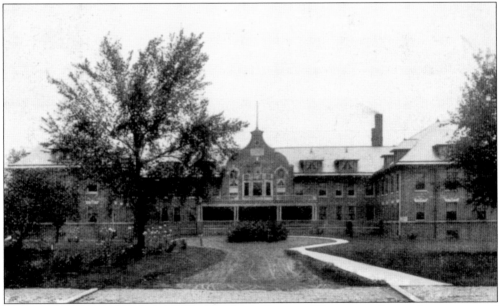

James Callahan established the Home for Aged Christian Women on the southwest corner of Eleventh and Pleasant Streets in 1896. A few years later, it moved to this facility on University Avenue and Twenty-eighth Street and became the Home for the Aged, expanding its mission to all elderly patrons. Its success was due to the hard work and dedication of staff and volunteers. (DMB.)

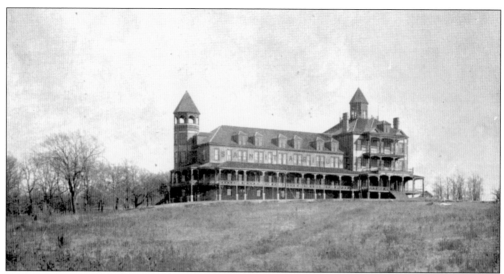

Hyde Park Sanitarium, located north of the fairgrounds in a parklike secluded area, was established for the healing of the mentally infirm. One of the many enterprises of George Jewett (lumberyard and scale company owner, typewriter manufacturer, publisher of Christian magazines, and Drake University secretary), the sanitarium applied principles springing from his fervent Church of Christ background and his stance for temperance and equality. (DMIS.)

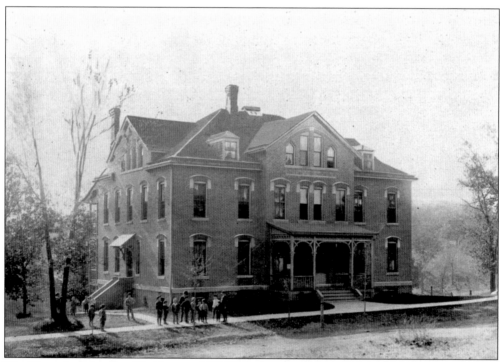

The Home for Friendless Children, at 2018 High Street, was one of many orphanages in the Des Moines area, including the Tracy Home, Iowa Children's Home, and the Benedict Home. As deaths of parents were much more commonplace then, such group homes were often the only lifeline children had in their time of need. (DMIS.)

Six

RELAXATION

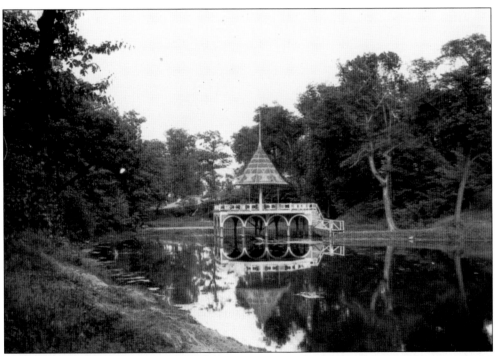

The Urban Parks Movement in Des Moines came on the heels of a much larger national movement in conservation during the latter part of the 19th century. In 1892, the Des Moines Park Commission voted to purchase several tracts of land to be used as park space by the city. The first purchase was for 60 acres east and north of Thompson's Bend, now known as Union Park. It opened in 1894 with great celebration. (HDM.)

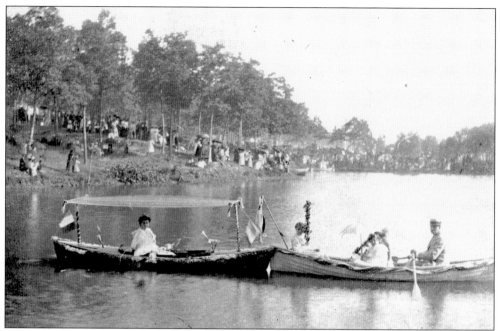

Greenwood Park was originally named Prospect Park and consisted of a consolidation of several tracts of land. The purchase was conditioned on the ability of the city to acquire all the proposed properties. The park lay at the end of the Ingersoll trolley line, making it accessible to the city's population. (DMAR.)

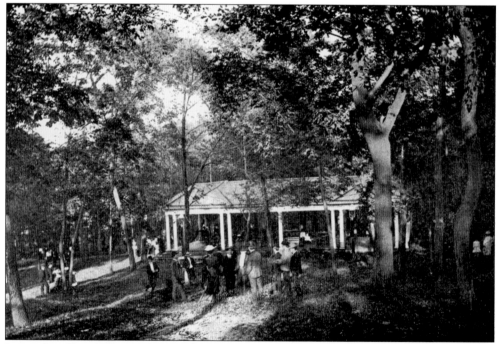

Located on Four Mile Creek, Grandview Park was named simply for the grand view available to visitors of the Des Moines city and valley. It also opened in 1894, while the golf course was added in 1902. (HDM.)

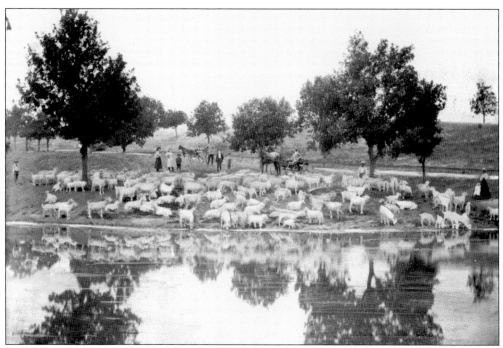

Waveland Park is home to the Drake Observatory and the Waveland golf course and tennis facilities. Before the golf course was constructed, however, it was an animal preserve featuring wild goats, elk, bison, and other prairie animals. (DMAR.)

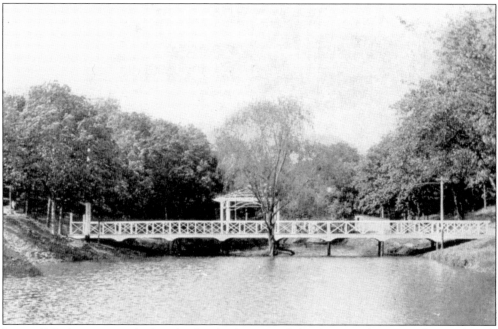

Ingersoll Park was named after the family that owned the farm on the original site. Though established along with other parks during this time, this park was a private enterprise built at the end of the trolley line. It featured a roller coaster and other rides, as well as a bandstand for concerts. (DMAR.)

Another aspect of civic life that changed the way people viewed parks was the automobile. Scenic drives, such as Birdland Drive into Union Park, offered access to remote venues that had previously been inaccessible. (DMB.)

This is the entrance to Union Park. The Urban Parks Movement was largely successful due to the beautification efforts by the women of the city and the addition of great expanses of unoccupied land in the annexation of 1890. At first, these parks were little more than nature preserves. However, through civic investment and improvement, they have become the jewels of one of the best park systems in the country. (DMAR.)

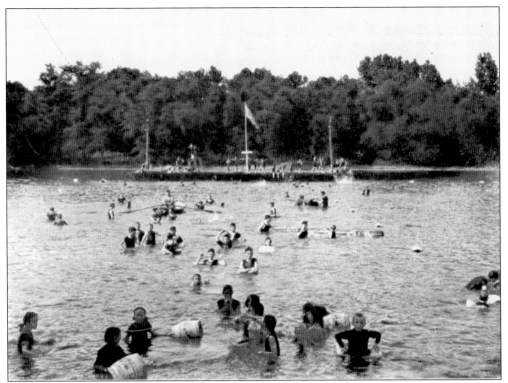

Swimming was largely a personal affair, done in whatever relatively clean lake or river seemed handy. Public swimming beaches and pools began to be developed after accidents and pollution made the occasional swimming hole less appealing to the general populace. Many parks had lakefront swimming, while others such as Birdland had public bath houses and swimming pools. (HDM.)

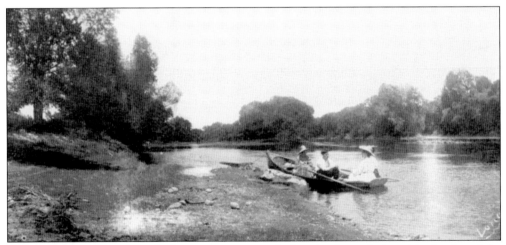

Pleasure boating was also a fairly recent activity, which gained popularity with the rise of the middle class. A picnic lunch on a Saturday afternoon along the unpolluted upper Des Moines River, in view of the many mansions and custom homes that lined the riverfront, was just the thing to relax from a hard week's work. (DMB.)

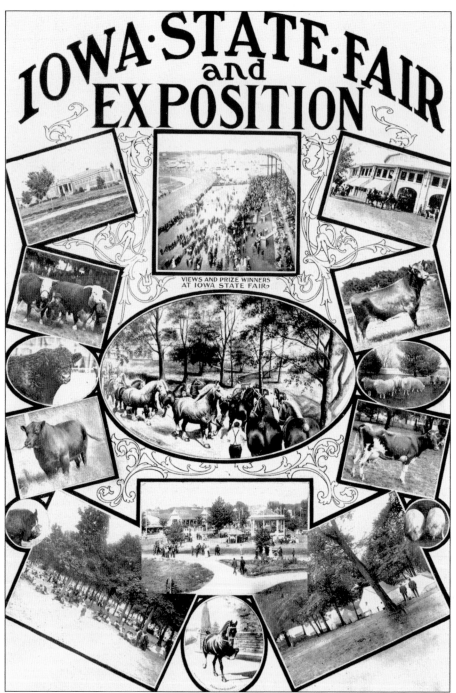

VIEWS AND PRIZE WINNERS AT IOWA STATE FAIR.

The Iowa State Fair was first held in 1854 in Fairfield and moved from city to city, until settling in Des Moines in 1879. Still, it was held in temporary venues for several years until a permanent place was found, and the fair relocated to its current home in 1886. Mostly oriented toward agriculture, in the 1890s the fair began offering spectaculars such as the staged train wreck in 1896, or the fireworks extravaganzas featured nightly until the 1930s. It remains the most popular attraction in Iowa, bringing more than a million visitors to Des Moines every year. (DMB.)

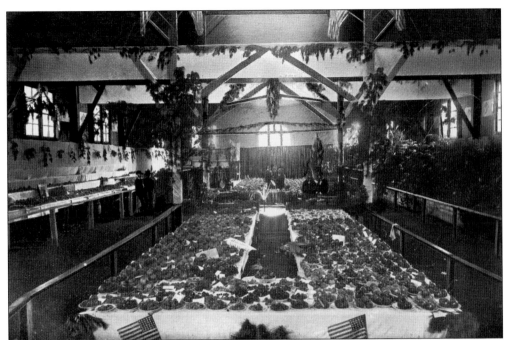

In Horticulture Hall, special breeds of flowers and arrangements were put on display at the fair of 1910. In early years, the fair was almost exclusively a display of agriculture and livestock; other events such as the city's Seni Om Sed celebration attempted to provide entertainment but were often unsuccessful. It was during this time that the famed "Butter Cow" was first displayed. (DMB.)

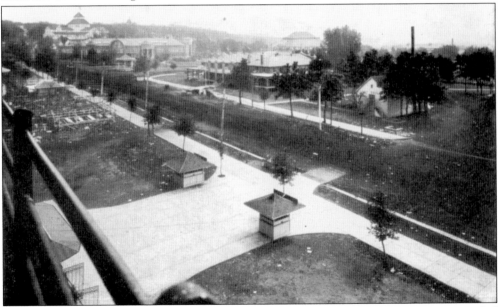

This view of the fairgrounds is also from 1910. As interest in the fair grew, it soon expanded its scope, first to entertainment, with wild evening fireworks spectaculars, then to displays in commerce, science, and art. Entertainment quickly turned to roller coasters and other boardwalk attractions. The Iowa State Fair became the model for other state and county fairs and was featured in several early Hollywood movies. (HDM.)

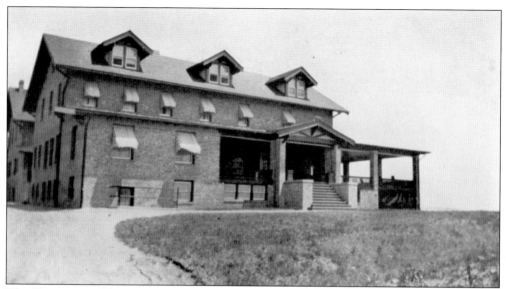

The Hyperion Field Club was founded in 1900 as an athletic organization. Originally near Waveland Park, the club moved to its present facility on Beaver Road, then adjacent to an interurban station. Purchasing 220 acres, the club featured golf, automobile touring, tennis, archery, and other activities. (HDM.)

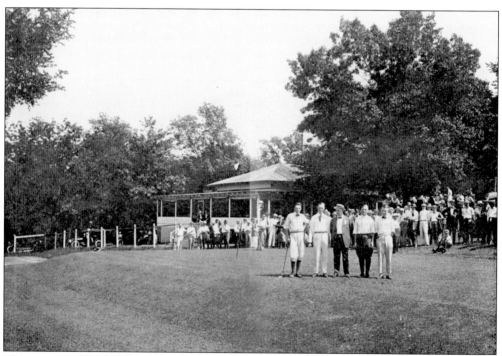

The sport of golf took hold in the Midwest at the beginning of the 20th century, and Des Moines was no exception. The Des Moines Country Club sponsored many events, including this 1913 charity match for the American Red Cross. These events would be the precursor to modern-day golf tournaments. (DMAR.)

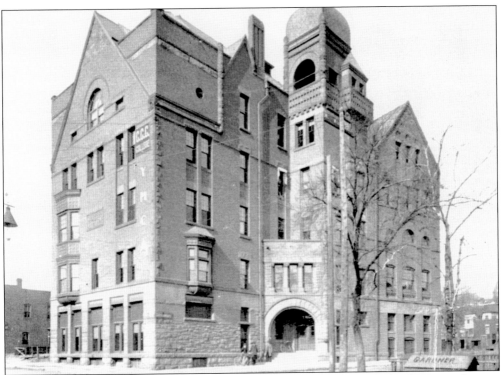

Founded in 1868, the YMCA encouraged both the physical and spiritual development of young men. This facility was located on the northwest corner of Fourth Street and Grand Avenue. Eventually the organization built a larger fireproof building at Fourth and Chestnut Streets and maintained an athletic field on South Ninth Street. (DMIS.)

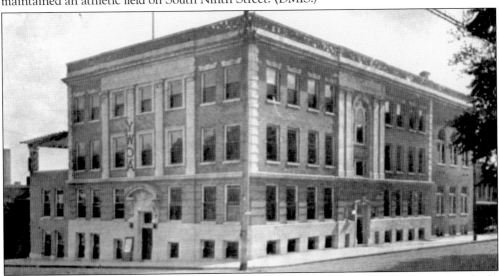

The Des Moines YWCA, organized in 1895, soon developed a membership in the hundreds. Located in the Redhead Block at the southeast corner of Fourth and Locust Streets, it eventually outgrew even this facility and relocated to Ninth and High Streets. Residents in its dormitories were provided with a balanced life curriculum in religious studies, physical training, domestic training, art and science, and other educational classes. (HDM.)

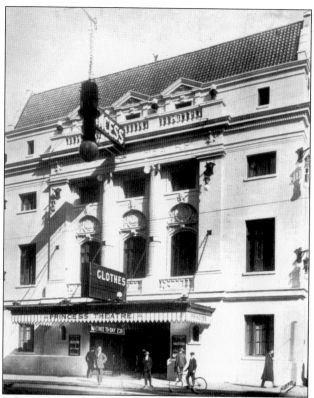

The Princess Theatre, at 317 Fourth Street, founded by Elbert and Getchall, was the premiere theatre in Des Moines, offering live entertainment and stage plays. It was the starting place for many vaudeville, stage, and movie stars, including Anita King, Conrad Nagel, Fay Bainter, and Ralph Bellamy. (DMB.)

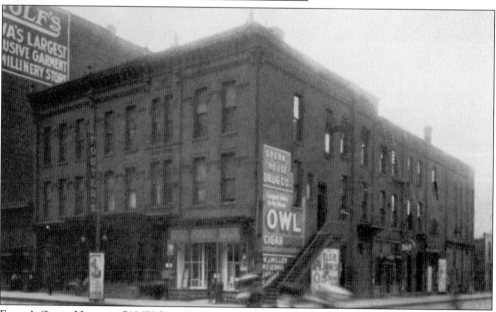

Foster's Opera House at 718 Walnut Street was built by William Foster, owner of an architectural and construction firm. It was one of the few places residents could see opera and other spectaculars in all their glory. It was also the starting place for many actors and actresses, and at least one anthem; "The Song of Iowa" (made the state's official song in 1911) debuted at the opera house in 1897 to much acclaim. (HDM.)

Seven

HOMETOWN

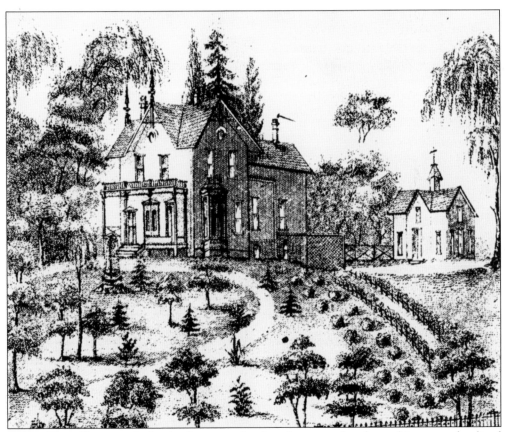

Before Hoyt Sherman built the house and cultural center that bears his name, he lived in this nearby residence. Probably the most well-known city founder, he held a number of private and public offices and remained active in the community. After his death, the Des Moines Women's Club took over his house, building an art gallery and theater. It continues to be used as a conference and entertainment center offering a variety of events. (Atlas.)

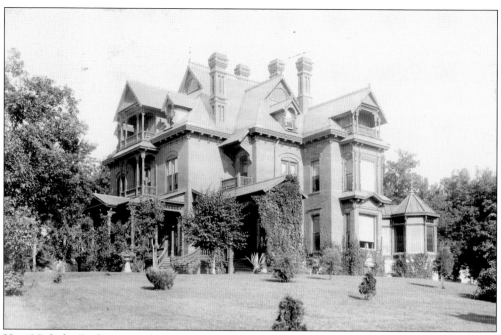

Hon. Nicholas Baylies, an early pioneer, businessman, and civic leader in Polk County, lived in this house at Thirty-third Street and Grand Avenue (now the site of Windsor Terrace Apartments), which was built in an elegant Victorian style. His son Frank Baylies lived in the house for a time after the judge's death in 1893, but it was later purchased by Alfred J. Pearson. (DMPL.)

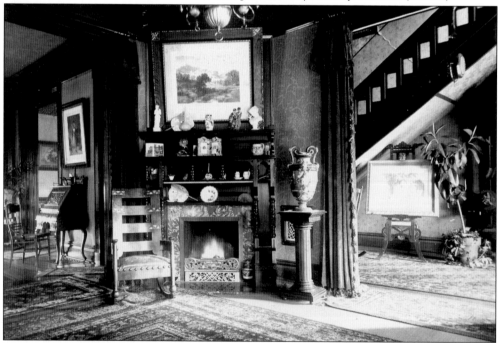

The parlor in the Baylies house was a formal sitting room used for guest entertainment and also the visitation of the recently deceased. Because of the association of a parlor with burial and grieving, early-20th-century architects rechristened it the "living" room. (DMPL.)

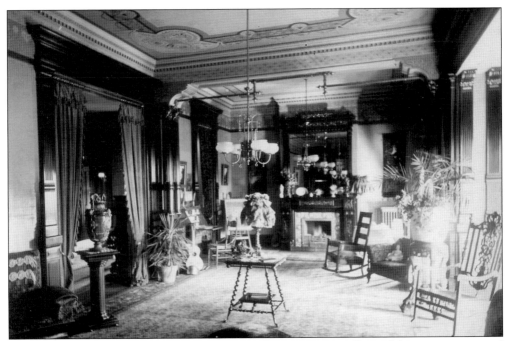

A drawing room such as this one in the Baylies home was typically used for more private and intimate conversations. Here small groups could withdraw from the main gathering of a party or social event. (DMPL.)

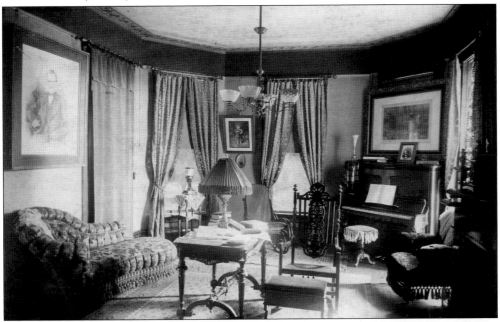

Before the days of broadcast radio and television, families had to entertain themselves, often in the music room (or for those less fortunate, in the parlor with a house organ or handy fiddle). Magazines and journals would typically print several new pieces of music every issue, and poetry and song writing were common forms of expression. These family entertainments are an aspect of life sorely missed today. (DMPL.)

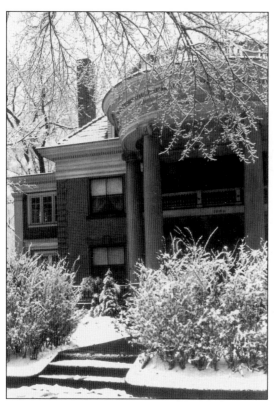

Rev. George Peak was the president of the Central Life Association Society of the U.S. (now known as AmerUs). He built this Colonial Revival home at 1080 Twenty-second Street in 1900. Listed in the National Register as the New Life Eternity House, it now serves as a center of ministry for interfaith renewal. (DMPL.)

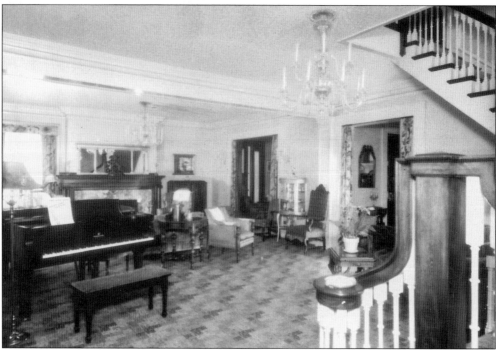

The simple yet elegant living room of the Peak House was used to entertain many of the reverend's associates. Doorways led to the formal dining room, sun room, and library. (DMPL.)

Arthur Hanger, an optician and jeweler, lived at this residence at 1314 East Ninth Street (now the site of a medical clinic). His daughter appears on the steps in this photograph. The 45-star flag hanging on the porch was used between 1896 and 1908. (DMPL.)

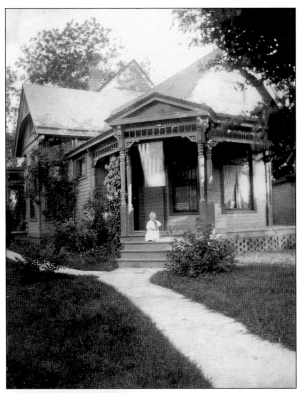

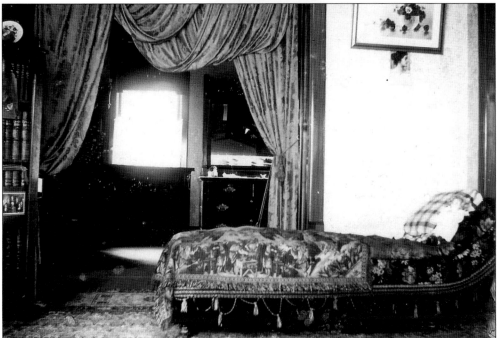

The lounge in the Hanger home provided an informal family gathering place, with a small alcove as an office. In the 20th century, the lounge was also replaced by the living room, although it is still common in Britain and other commonwealth nations. (DMPL.)

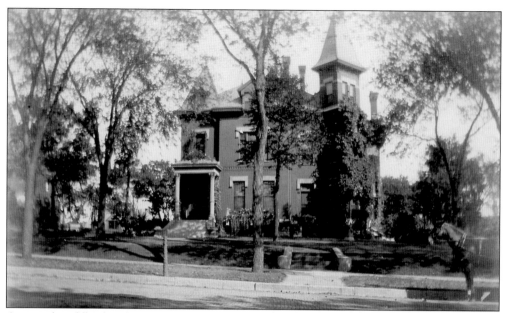

A typical middle-class family of the 1890s lived here in the Miller home. Rev. William Miller served as pastor of Westminster Presbyterian Church from September 23, 1891, to September 15, 1892, but his stay in Des Moines appears to have been much longer. His address in the 1897 directory is listed as "e s Park Lane, 3 s of Grand," probably on Forty-fourth Street near Greenwood Park. The following photographs were taken at the Park Lane home. (DMPL.)

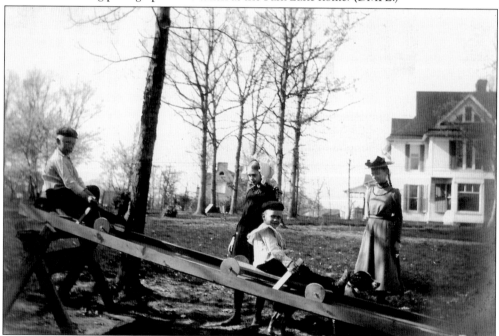

The Miller sons, Paul (left) and Seymore, have managed to design a ramp to drive their makeshift go-carts, while their sisters look on in amusement. They must not have lost their enthusiasm for speed, since several other images in the archive show them as adults, riding motorized bicycles and attending races. (DMPL.)

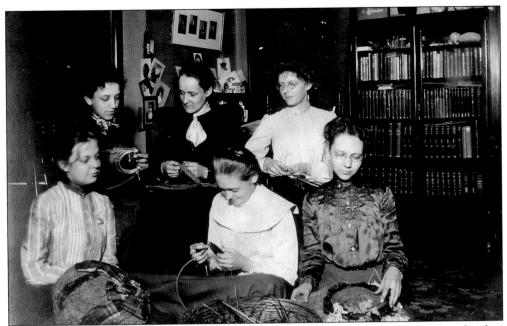

Mrs. Miller teaches a basket-weaving class in the study of the Park Lane home. It is hard to believe now, but at the end of the 20th century, most teenagers stopped going to school after the eighth grade; if they did go to high school, it was to learn a trade or prepare for college. Most working skills were instead passed from parent to child or through apprenticeships. (DMPL.)

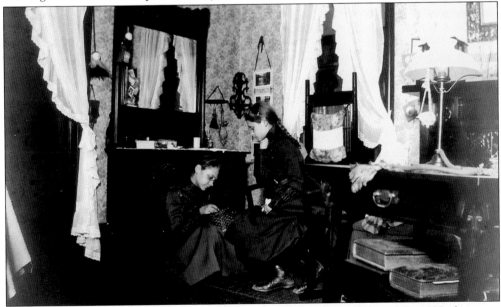

The Miller daughters, Nellie (left) and Mabel, prepare for Sunday services. By 1897, they were both boarding in other homes. Mabel (around 17) was working as a baker on Sixth Street, and Nellie (around 11) was in a house on Twenty-fourth Street, possibly as a live-in maid, as such temporary arrangements were common for preteens at this time. The 1905 annual of West High School shows that Nellie contributed to the school newspaper and graduated that year with high honors. (DMPL.)

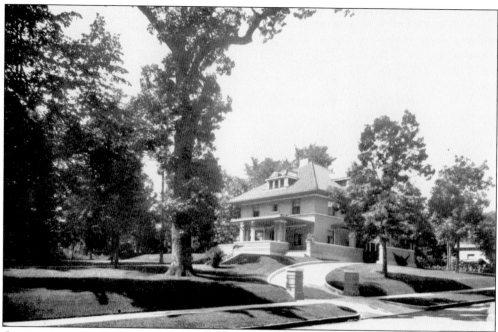

George Henry France built this house at the corner of Oakland and Franklin Avenues in the River Bend area in the early 1900s. His primary businesses were loans and real estate, but he and his wife were also involved in many charitable and philanthropic activities and hosted many social events at their home. The house was converted to apartments in the 1940s. (DMB.)

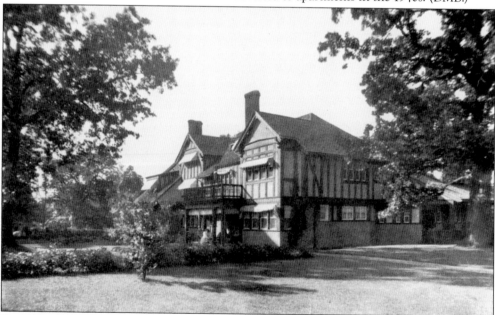

David S. Chamberlain, president of the Chamberlain Medicine Company (at the time the largest medicine supply company in Iowa), lived in this house at 3520 Grand Avenue for many years. The company's success attracted competition, and by 1910 no less than 25 medical supply businesses were operating in Des Moines. The house was later converted to a sanatorium and is now the property of the Wesley Retirement complex. (DMB.)

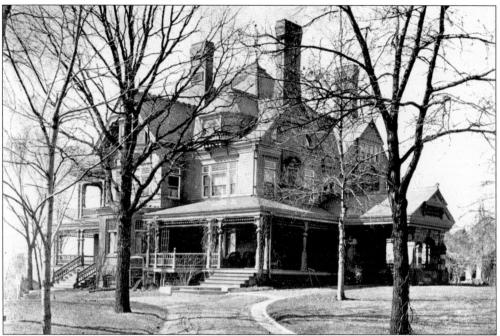

Jefferson S. Polk was one of the organizers, along with Hoyt Sherman and Fred Hubbell, of the Equitable Life Insurance Company. He also served as the president of the Des Moines City Railway Company (among other ventures) and lived at Herndan Hall at 2000 Grand Avenue, now the site of the Meredith Corporation office complex. (DMIS.)

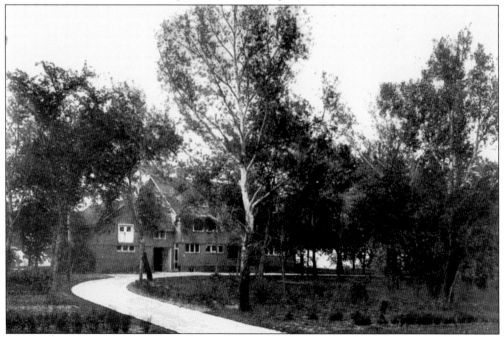

Simon Casady, the son of P. M. Casady, worked as cashier of Des Moines National Bank, then president of State Central Bank. He lived in this home at 718 Fifth Street (now the site of a parking garage), just down the street from his father's residence. (DMB.)

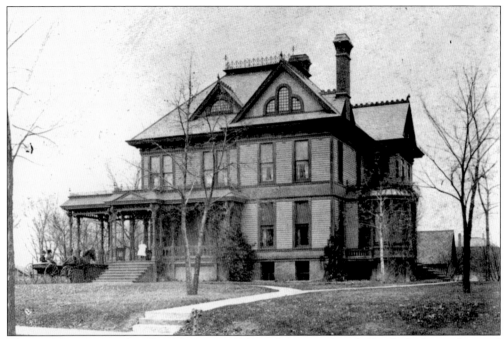

Thomas Hatton moved to Des Moines in 1861 and partnered with Frank A. Percival in real estate ventures. He also did work for the railroad and served two terms as city treasurer. He lived in this house at 2007 Grand Avenue for many years (now the site of a parking lot for the Iowa Lottery Commission). (DMIS.)

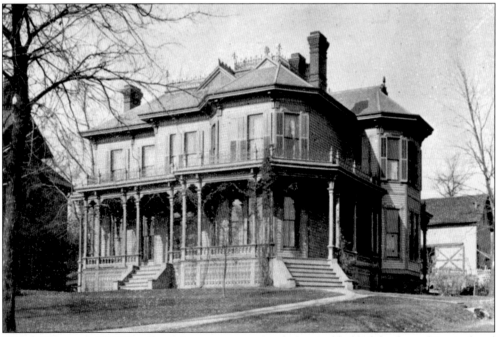

This residence, at 1417 Woodland Avenue, represents the second half of the firm of Percival and Hatton. In addition to his interests in that firm, Frank Percival was president of the Iowa Pipe and Tile Company. The lot is now the home of the Iowa Methodist Medical Center. (DMIS.)

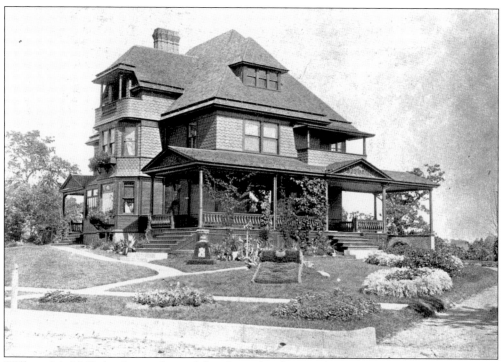

William M. McFarland, president of the Central Life Assurance Society, also served as Iowa secretary of state from 1891 to 1897. He lived in this house at "Arlington Avenue, 2 east of Sixth Avenue" in the River Bend area. The structure has since been torn down to make way for an apartment complex fronting the Des Moines River. (DMIS.)

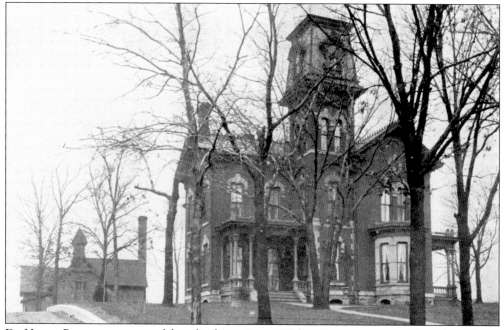

Dr. Homer Potter ran a successful medical practice on Walnut Street, returning after a busy day to this home at 1135 Pleasant Street, now the site of the Iowa Methodist Medical Center. (DMIS.)

Conduce H. Gatch was the senior partner of Gatch, Connor, and Weaver, one of the leading law firms in the state at the time. He was elected district attorney of Polk County and state senator (twice), but retired from politics to devote his full attention to the business of his firm. He lived in this house at 816 Seventh Street (now the site of a parking garage) until his death in 1897. (DMIS.)

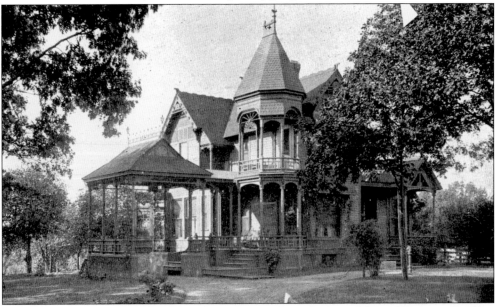

William Foster achieved the role of senior partner in the architectural firm of Foster and Liebbe, which specialized in the construction of public buildings. It designed a number of county courthouses and numerous college and university buildings for the state of Iowa. When Foster retired in 1898, he opened Foster's Opera House at 718 Walnut Street. He lived at this residence at 3920 Grand Avenue, near Greenwood Park (now the site of Barbican Condominiums). (DMIS.)

F. Wolcott Webster, who had a photography studio on Walnut Street, owned this home at 820 Fourth Street. Several of his scenes are featured in this collection. The residence currently standing on this lot was built in 1953. (DMIS.)

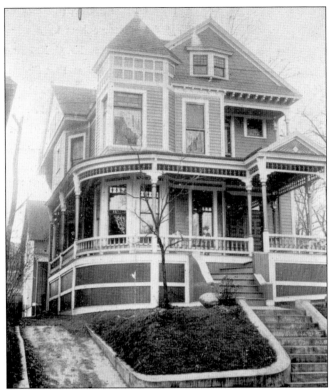

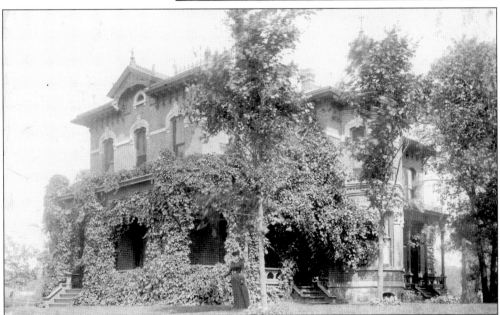

This residence, at Forty-second Street and Ingersoll Avenue, is listed in archives as the Pearson home and was possibly occupied by Alfred J. Pearson before he purchased the Baylies home (a close-up view of the desk in the parlor shows a photograph of this home). Ambassador Pearson was a professor and dean at Drake University before his appointment as a United States minister to Poland and then to Finland. (DMPL.)

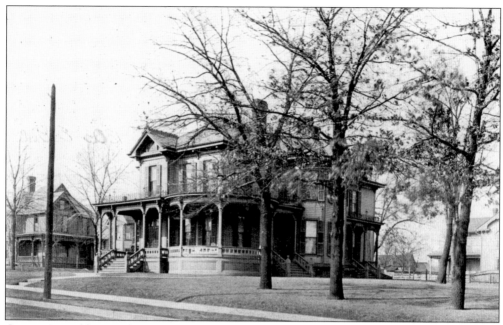

George Reynolds, president of Des Moines National Bank, lived in this house at 1623 Center Street in the Sherman Hill district. Built in 1882 in the Italianate style, it is listed on the National Register as the Maish House and remains a private residence today. (DMIS.)

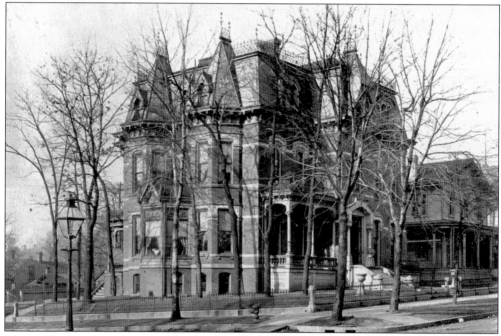

Owner of a furniture and carpet business on Walnut Street, Louis Harbach lived in this house at 802 Fifth Street. It must have been quite a busy household, since the 1897 city directory lists five other adults living at this same address, including William Harbach, who sold undertaker supplies, and Wilmot, who worked as a clerk in his father's store. (DMIS.)

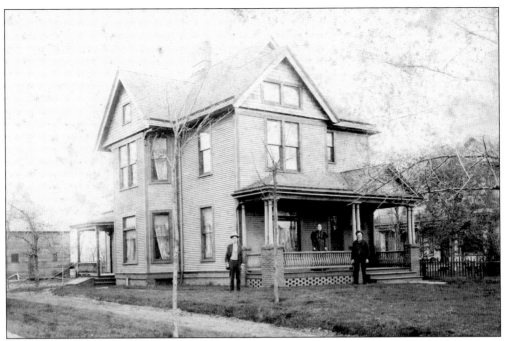

J. J. (left) and Lizzie Moore were insurance agents selling fire coverage out of the Iowa Loan and Trust Building through the firm of Moore and Moore. They lived in this house at 1320 East Ninth Street and Hubbell Avenue (now Roosevelt Drive). Pictured with them is their son Arthur. (DMPL.)

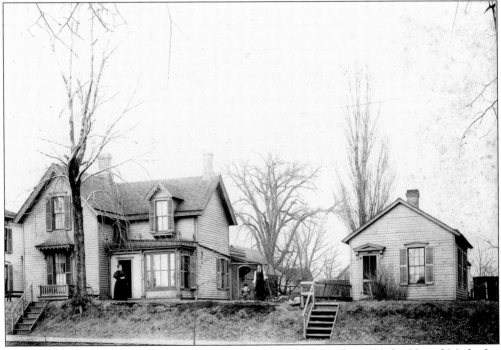

Alfred Jarvis and his family lived here at 823 East Twelfth Street (now Wesley United Methodist Church). Jarvis, a carpenter by trade, is joined by his wife and child in this photograph. (DMPL.)

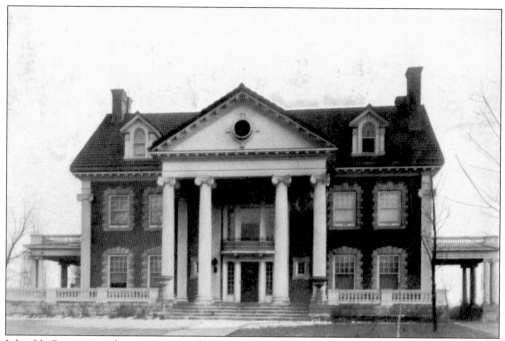

John H. Cownie was born in Scotland and immigrated to Iowa in 1856. Along with his partner, Jacob Bayer, he ran a livestock and tanning business in the 1890s. He also owned and managed the Cownie Glove Company. Later, he became a member of the State Agricultural Society and the State Board of Control in 1899. He occupied this house at 3118 Grand Avenue (now the site of the College of Osteopathy). (HDM.)

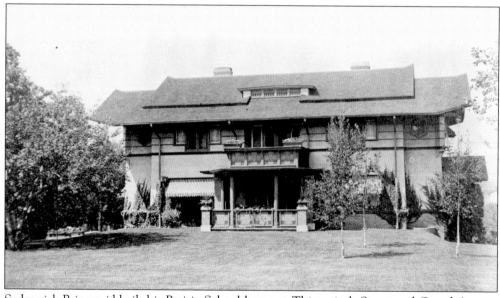

Sedgewick Brinsmaid built his Prairie School home at Thirty-sixth Street and Grand Avenue in 1901. Rumors persisted, but were never proven, that Frank Lloyd Wright designed the house, but it was widely acknowledged as the first arts and crafts home built outside of Chicago. Being a glass merchant, Brinsmaid included many art deco stained-glass pieces in his home, which had no parallel in the country. It was demolished in 1971. (LOC.)

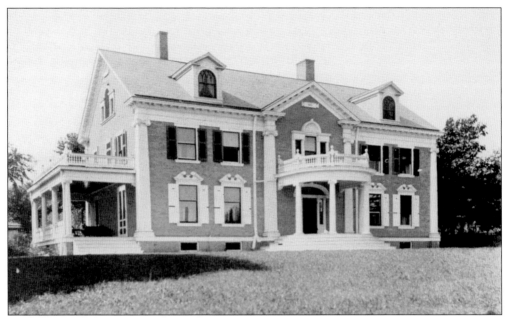

The Witmer house, located at 2900 Grand Avenue, was built in the Georgian Revival style in 1905. In 1947, it was purchased by the state of Iowa to be used as the governor's mansion (before this time the governor had been responsible for providing his own housing while in office). After 1971, it was briefly used as the home of the Iowa Girls Athletic Association, but was eventually sold by the state, and is now a private residence. (LOC.)

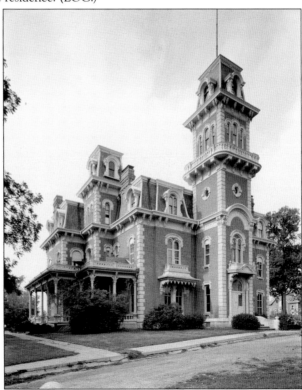

At 2300 Grand Avenue, Terrace Hill was built in the Second Empire style by B. F. Allen in 1869 at a cost of $250,000. Events at the house were spectaculars that drew people from as far away as Chicago and St. Louis. Purchased by Fred M. Hubbell in 1884, it was a family residence until 1971, when it was donated to the state for use as the governor's mansion. (LOC.)

Kingman Boulevard in western Des Moines was one of the first new roads built specifically for automobile traffic. Located between Drake and Waveland Parks, it was a primary center for upscale housing in the early 1920s. (DMPL.)

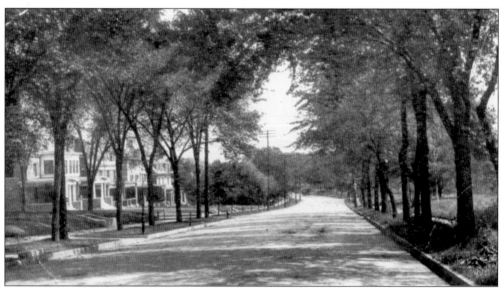

Grand Avenue was another upscale boulevard, with many of the more successful entrepreneurs in Des Moines settling south of the road. Access was provided early on through steam trolleys, and then electric; it was a quick hop downtown, whether the person was the president of a financial firm or a laborer in construction.

Eight

A NEW CENTURY

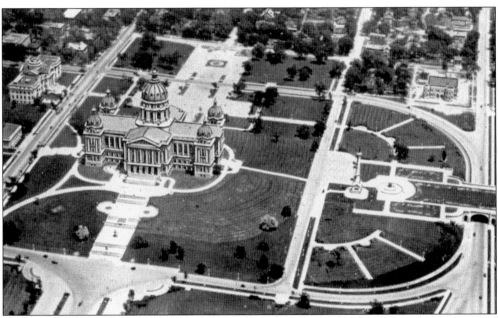

The 20th century brought more than just aerial photography to Des Moines. One of the more significant activities was the beautification effort undertaken by several women's clubs. The capitol also received a face lift when the grounds were expanded from 9 acres to 76. Many of the older homes and other buildings were removed as part of this effort, and a park atmosphere around the capitol emerged.

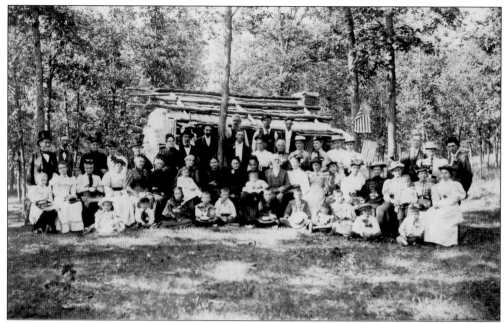

The semicentennial of Des Moines, celebrated in 1896, provided many opportunities for pioneers of the city to gather and share their stories, many of which were collected in histories of the period. One commentator at the time thought it remarkable that not 70 years before, a Sauk camp had sat on Capitol Hill, unmolested by the white man's presence. (DMPL.)

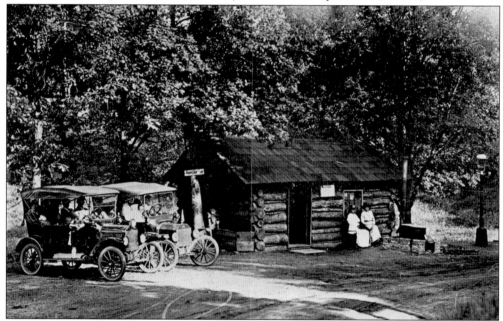

Replicated log cabins were in vogue at the time, and several were built in local venues, such as this one in Union Park. A movement was underway to re-create the old Fort Des Moines, or at least a good portion of it, on public land now occupied by Sec Taylor Stadium. However, interest in the project waned and only one authentic log cabin, originally from the 1840s, was relocated to the site. (DMAR.)

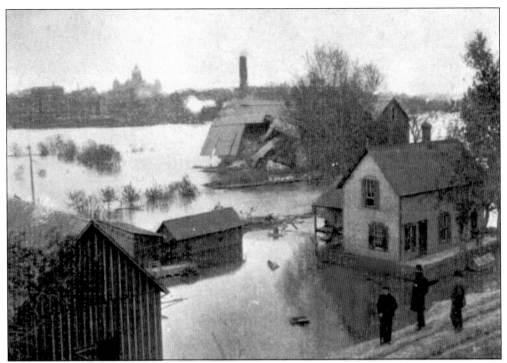

Late in May 1903, a tornado ripped through southern Des Moines. This was followed by extremely heavy rains for several days, until the flood reached 23 feet above high mark, creating a vast lake across the heart of Des Moines dotted with half-submerged homes. Though not as severe as the 1851 flood, it caused much greater damage. (BTH.)

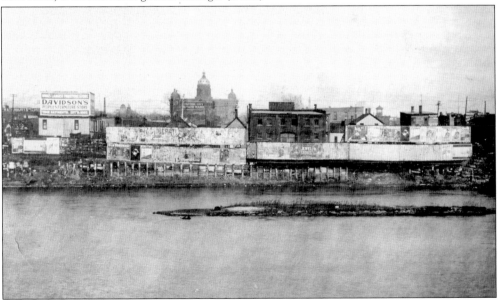

By 1909, the Des Moines riverfront had become an assemblage of old buildings, billboards, and pilings still left exposed from the 1903 flood. When a new progressive movement took control of the city government, a beautification effort was organized with the goal of a new civic center along the river, in the center of the city. (DMPL.)

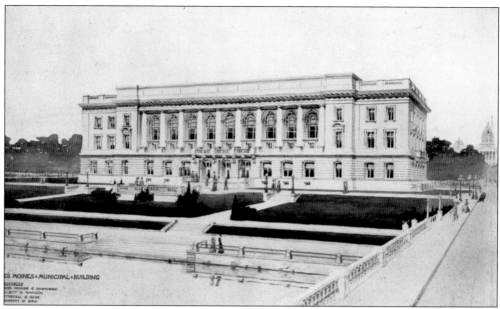

The new municipal building, as seen in this architect's drawing, was the centerpiece for a renewed civic center along the Des Moines River. It was the result of a progressive movement in city politics, resulting in the reorganization of the municipal government to a commission form. That dream was mostly realized, with many government and public buildings relocating to this location around that time. (DMAR.)

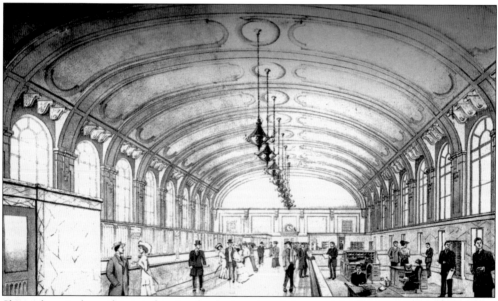

Shown here is the architect's drawing for the interior of the municipal building. The Des Moines Plan of city government called for a non-partisan city council elected at-large (rather than by ward), with non-elected administers of the city's departments. Public scrutiny and accountability was accomplished via annual reports, the first of which was published in 1908. This plan survived until 1950, when a mayor-council organization was established. (DMAR.)

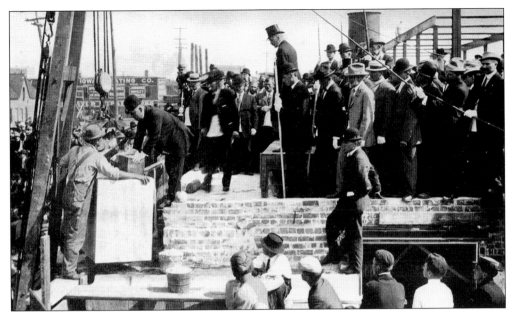

The cornerstone of the municipal building was laid on June 14, 1910, to great fanfare and was preceded by a parade of Des Moines's finest—from police officers to civic groups, and even the 6th Cavalry. From this building would come such improvements as permanent roads, more consistent city services, and improved health laws. (DMAR.)

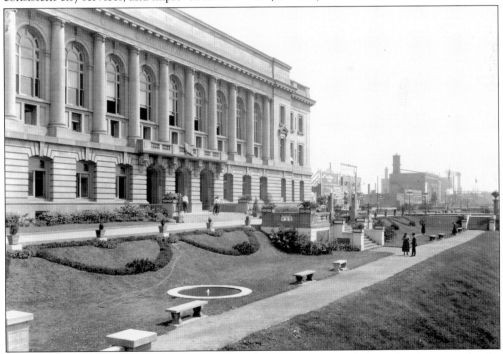

In addition to the improved civic amenities, parks were constructed along the river to make the complex more attractive. Unfortunately, in later years, many of these facilities would have to be removed for flood control and other construction efforts, after floods in the 1950s and 1960s again threatened the city. (DMAR.)

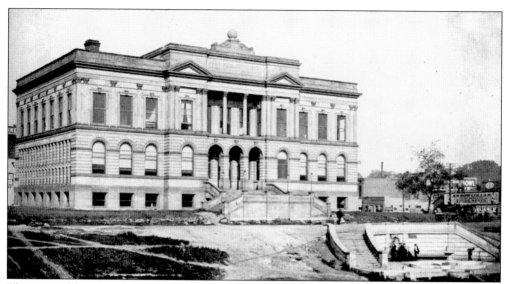

The new public library opened in 1903 and proved to be the cornerstone of a new flurry of civic building along the Des Moines River. For a time, it also housed the Cumming School of Fine Art on its upper floor. Serving as the center of a library system spanning six separate facilities, it transferred to its new building at 1000 Grand Avenue in 2006. This building is now home to the World Food Prize Foundation, funded by the John Ruan Trust. (DMPL.)

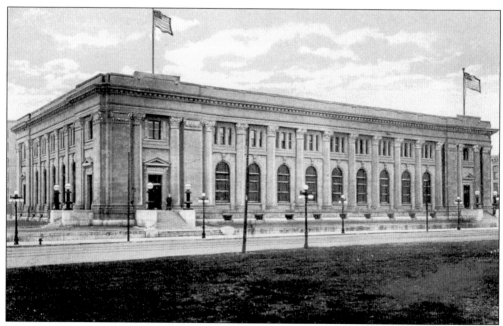

The post office was also moved from the federal building, near the Polk County Courthouse, to this location on 100 Walnut Street, next to the library. The national courts continued to meet in the old federal building until they were moved to the civic center in 1928. This structure now houses the Polk County historical gallery.

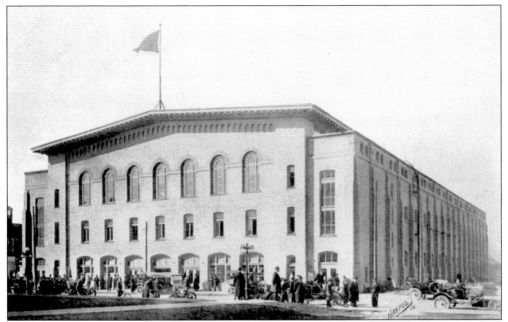

The Coliseum was built across the street from the library for $150,000—financed entirely by subscription—and was proof to many that the progressive movement that had taken control of the city government would do great things. The Coliseum hosted sporting events, conventions, and other public gatherings for many years. (DMB.)

This Carr and Adams Company display appeared at the Des Moines Made Goods Show at the Coliseum in 1910. The firm manufactured windows, doors, and other home accessories. Built to be fireproof, the Coliseum nevertheless burned down on August 13, 1949, to the shock of the entire city. Almost immediately, a movement arose to build a new event center: the Veterans Memorial Auditorium. (DMB.)

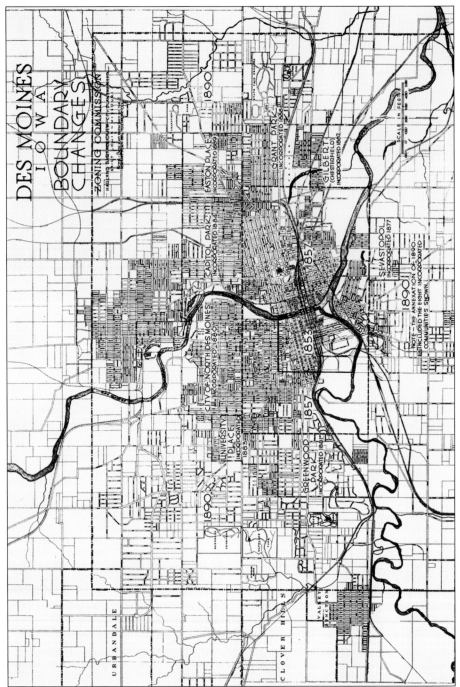

This map shows the extent of growth that Des Moines experienced by the early 1920s, the greatest of which came through the consolidation of eight suburbs into the city limits. This extension of the boundaries of Des Moines, which occurred in 1890, expanded the city from its 1857 area to one larger than Boston, Pittsburgh, or San Francisco at the time. Communities that were absorbed included Sevastopol, North Des Moines, Greenwood Park, Gilbert (Chesterfield), University Place, Capitol Park, and Easton Place. (MSPDM.)

CORRECTION OF JOGS IN UNIVERSITY AVE.

b—University Avenue connection between Sixth and Ninth. This project has been under consideration for some time and every year becomes more costly and difficult of accomplishment. There is no disagreement as to the necessity of making University Avenue a continuous thoroughfare by the elimination of all such faults as are involved here. The method only is in question. It appears now that the most practicable and inexpensive plan would be to extend this street practically straight through the property between Sixth and Ninth, as shown on the plan above.

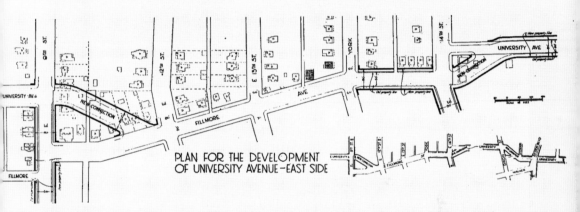

PLAN FOR THE DEVELOPMENT OF UNIVERSITY AVENUE—EAST SIDE

c—University Avenue on the east side also requires correction. The most feasible way of carrying this very useful thoroughfare continuously through the east side is to connect it with Filmore Street. The detailed plan appears above.

The advancement of the automobile resulted in a significant shift in city planning philosophy. Streets designed for horses and carts suddenly had to support fast-moving automobiles and motorized trucks. Thoroughfares needed to be constructed to allow the increased traffic to move in, out, and through the city. In some cases, misaligned street venues needed to be corrected to allow for smooth connections between city centers. In this example from a planning study on road infrastructure in Des Moines, corrections to several areas on University Avenue are proposed to allow continuous traffic flow through the city. (MSPDM.)

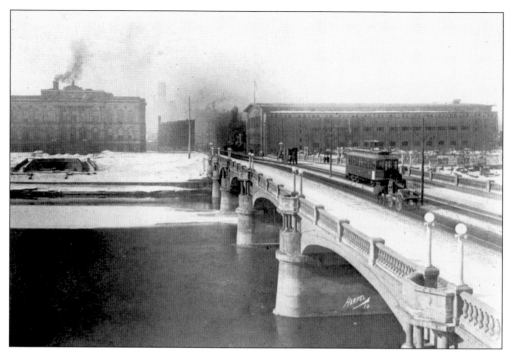

This view of the river in 1910 shows that, while significant progress has been made, much more would have to be accomplished. The Locust Street bridge was reconstructed, and soon the other bridges would follow. Parkland would be expanded, and new government buildings would be added. (DMPL.)

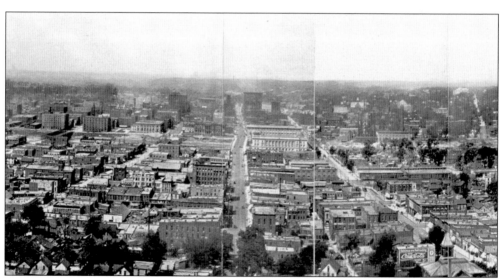

Downtown Des Moines can clearly be seen in this photograph from the capitol rotunda in 1912. The civic center is about complete, although there are beautification steps that still need to be taken. Revitalization of the downtown area, however, would not begin until the 1940s. (DMAR.)

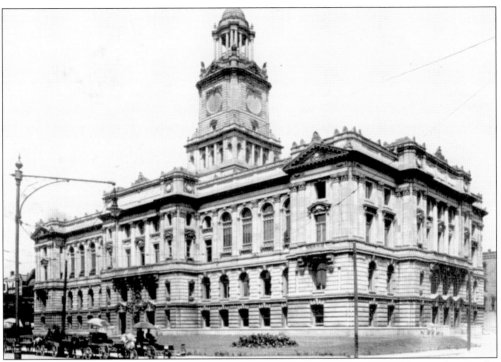

The old courthouse was deteriorating and needed to be replaced. Despite efforts to locate the new courthouse on the riverfront across from the library, construction on the new Polk County Courthouse was begun in 1902 on the site of the old courthouse. Built of limestone in the Classical Revival style, it was dedicated in 1907, with the final cost running to $750,000. (DMPL.)

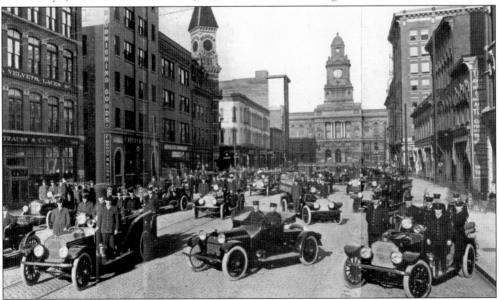

By 1912, the fire department had expanded to 15 trucks and 127 full-time firefighters, requiring a significant upgrade of equipment. By the end of the year, the department owned 11 hose wagons, an aerial truck, 4 hook and ladders, 11 chemical engines, 3 pumpers, and 2 chief's automobiles. (DMAR.)

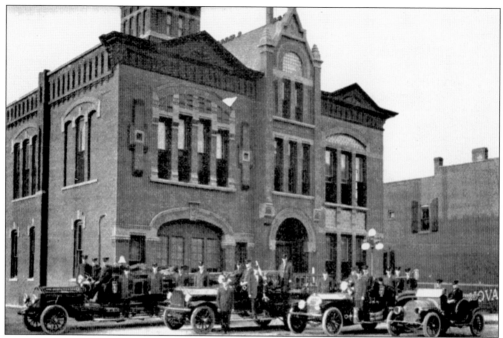

Firehouse No. 2, at East Fourth and Walnut Streets, owned a range of equipment, including a hook and ladder, hose wagon, chemical engine, and chief's automobile. A chemical engine used soda mixed with water to put out fires; in areas without strong water pressure, it was sometimes the only way to extinguish a blaze. (DMAR.)

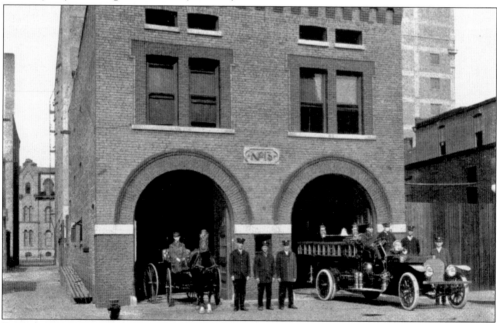

Some companies, such as Station No. 13 at Eighth and Plum Streets, continued to use horse-drawn wagons. There were a total of 39 horses still used by the fire department in 1912. After they served their usefulness, they were frequently used for public works projects and then retired to pasture to live out their lives as heroes of the city. (DMAR.)

By 1919, the riverfront had improved dramatically. The civic center was underway, and Parkland was being improved. Even the billboard signs were cleaned up and would eventually be removed. Nevertheless, beautification efforts would continue even into the 21st century. (DMPL.)

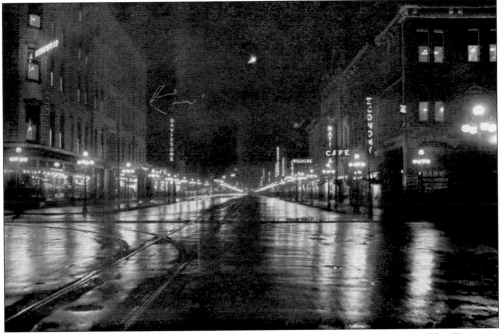

Another improvement to the city was the addition of street lighting. Illuminated by Tungsten Electroliers, Walnut Street was pronounced by *Electrical World* "The Best Lighted Street in the United States." Soon other streets in the downtown area were also lit, with the financial burden falling entirely on the business community of Des Moines. (DMAR.)

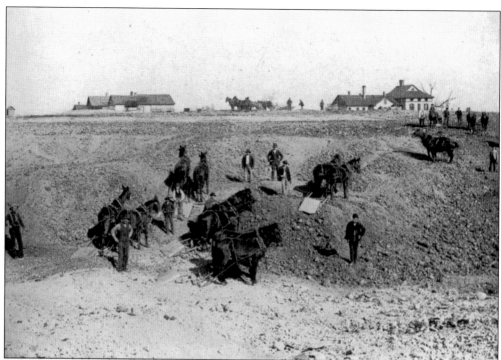

Groundbreaking for Fort Des Moines No. 3 began in 1903 about four miles south of the site of the original fort. It served as a cavalry post for several years, and also as an officer training school for African Americans during World War I. Later it became the first training center for the Women's Army Corps during World War II. To avoid controversy, the women resided in the Savery Hotel. (HDM.)

Officers were quartered in these barracks. Fort Des Moines was mainly a training center and veteran's hospital after World War II. Eventually, though, most of the buildings were closed, and the land was deeded back to the city. A small memorial and museum remains to this day. (DMPL.)

When America entered World War I, the training infrastructure was nonexistent. Camp Dodge was built in a matter of months and was used to train over 100,000 troops. After the war, the support staff was cut to one-quarter its original size, and many of the buildings remained vacant for years.

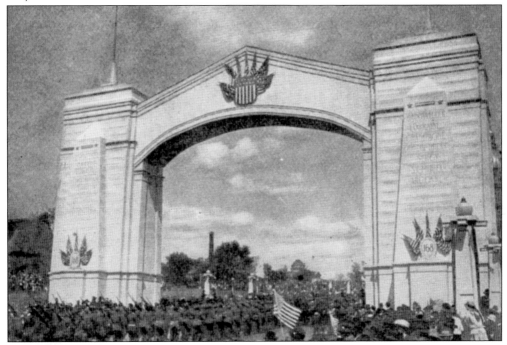

When the victorious troops returned from World War I, Des Moines greeted them enthusiastically by building a victory arch for their parade at the entrance to the capitol grounds. Although this arch remained for a while, like most other arches constructed for special events at the time, this one was torn down. (John H. Tabe.)

This car was built in 1909 by the Mason Auto Company, engineered by Fredrick Duesenberg. The company was sold to Maytag, who moved production to Waterloo. Duesenberg founded his own car company with his brother August and built many winning race cars in the early days of the automobile. (DMPL.)

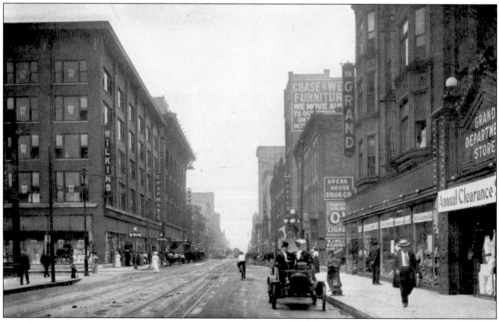

This view of Walnut Street, looking east from Eighth Street, shows the Wilkins and Chapmans department stores on the left. On the other side of the street are Foster's Opera House and, in the distance, one of the earliest moving picture theaters in the city. The Grand, which took over the Iowa Exposition Building when the Illiad Hotel closed its doors, is seen at the far right. (DMB.)

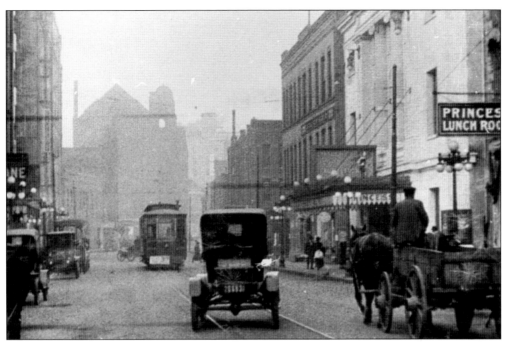

The early years of the 20th century proved to be a time of transition for transportation. Asphalt was laid over the existing streets to provide a smoother surface for automobiles. Trolleys became longer due to popularity and fully enclosed due to accidents. As for horses, they continued to be used on city streets into the 1930s. (IDOT, Bob Krouse.)

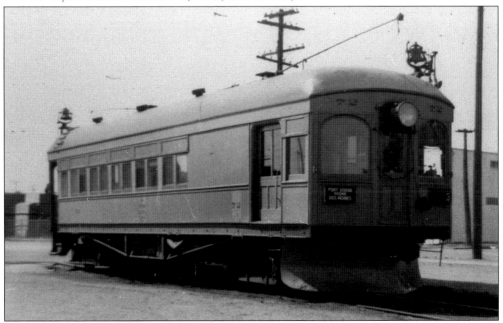

The Interurban Railroad of Central Iowa, founded in 1899, ran from Colfax to Perry and points in between. Using existing streetcar technology, interurbans provided a reliable means of passenger and freight transportation. In 1922, it was renamed the Des Moines and Central Iowa Railroad and later converted to electric-diesel use. (IDOT, Bob Krouse.)

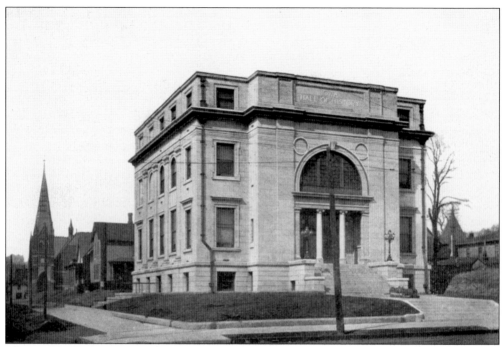

The Iowa Hall of History's foundation was laid in 1899. Soon after, it became known as the Iowa State Historical Building and was briefly used solely as a museum for historical relics related to the founding and history of Iowa. (DMPL.)

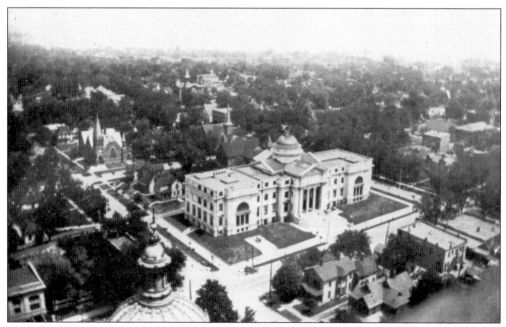

In 1910, the State Historical Building was greatly expanded, becoming the State Historical, Memorial, and Art Building. The original Hall of History is to the left, with its original stone steps removed. The structure is currently home to the Iowa State Library, and most of the surrounding buildings have been removed. (HDM.)

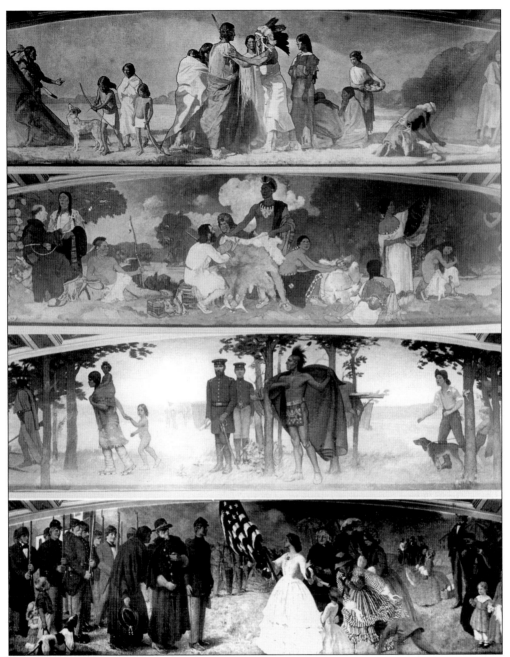

These four murals adorning the courthouse reflect the different eras of Iowa history: (from top to bottom) *The Indian Way of Life* by Douglas Volk, *The Missionaries Come* by Douglas Volk, *Indian Resettlement* by Charles Atherton Cumming, and *The Civil War* by Edward B. Simmons. At the beginning of the 20th century, there was a strong interest in history in Des Moines. Looking back to their roots and considering how the values and choices of their forefathers influenced their own lives, many became mindful for the first time about the legacy they would leave for future generations. (DMPL.)

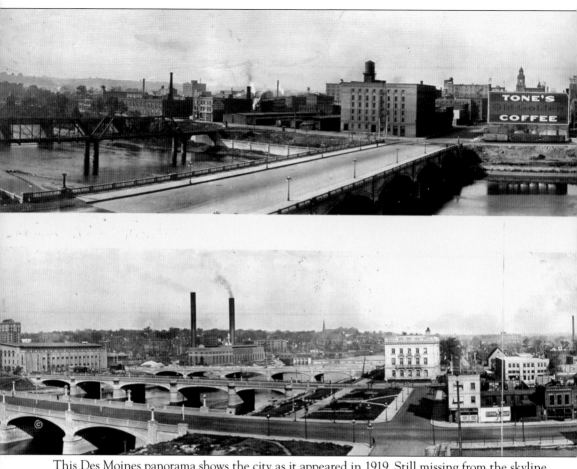

This Des Moines panorama shows the city as it appeared in 1919. Still missing from the skyline are the new Equitable Building, constructed in 1924; the new federal courthouse, built in the civic center in 1928; the Banker's Life building (now Principal), constructed in 1940; and many other

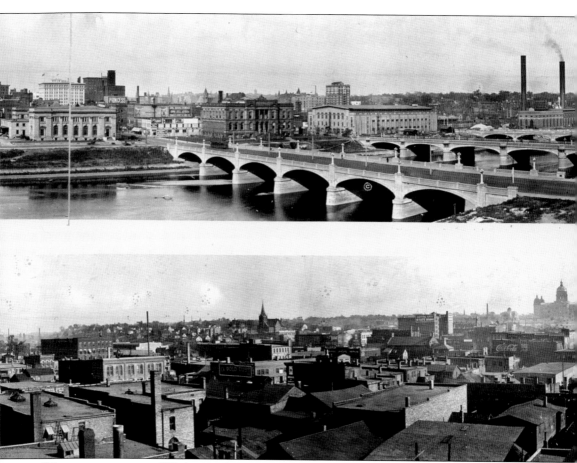

well-known attractions. While significant progress has been made, the greatest revitalization efforts would not occur until the latter half of the 20th century. (LOC.)

www.arcadiapublishing.com

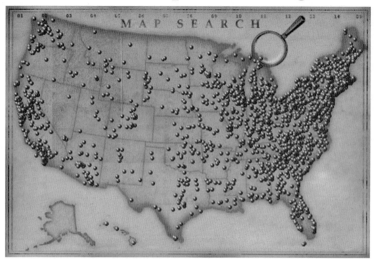

Discover books about the town where you grew up, the cities where your friends and families live, the town where your parents met, or even that retirement spot you've been dreaming about. Our Web site provides history lovers with exclusive deals, advanced notification about new titles, e-mail alerts of author events, and much more.

MADE IN THE USA

Arcadia Publishing, the leading local history publisher in the United States, is committed to making history accessible and meaningful through publishing books that celebrate and preserve the heritage of America's people and places. Consistent with our mission to preserve history on a local level, this book was printed in South Carolina on American-made paper and manufactured entirely in the United States.

This book carries the accredited Forest Stewardship Council (FSC) label and is printed on 100 percent FSC-certified paper. Products carrying the FSC label are independently certified to assure consumers that they come from forests that are managed to meet the social, economic, and ecological needs of present and future generations.

FSC
Mixed Sources
Product group from well-managed
forests and other controlled sources

Cert no. SW-COC-001530
www.fsc.org
© 1996 Forest Stewardship Council

Find Your Place in History.